CW00547583

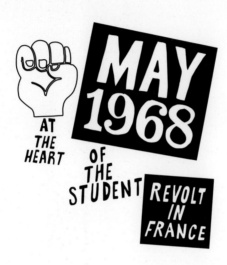

MAY 1968

AT THE HEART OF THE STUDENT REVOLT IN FRANCE

PAGE 4. Boulevard Saint Germain, 6th arrondissement, Paris, May 6th. Contact sheet of student protests.

PAGE 6. Ecole des Beaux-Arts, 6th arrondissement, Paris. Most of the posters that made their appearance during the May 68 event were created here.

Editor > MCM

Proofreading > Barry Winkleman

ISBN > 978-981-4610-68-1

Color Separation > Sopedi, France

Editions Didier Millet

78 Jalan Hitam Manis, Singapore 278488

www.edmbooks.com/

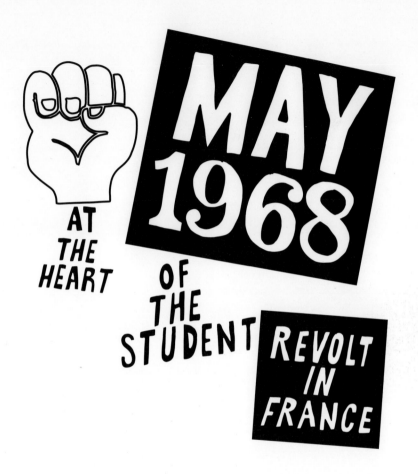

MAY 1968

AT THE HEART OF THE STUDENT REVOLT IN FRANCE

PRESENTED BY

PHILIPPE TESSON

AS WITNESSED BY

BRUNO BARBEY

ÉDITIONS DIDIER MILLET

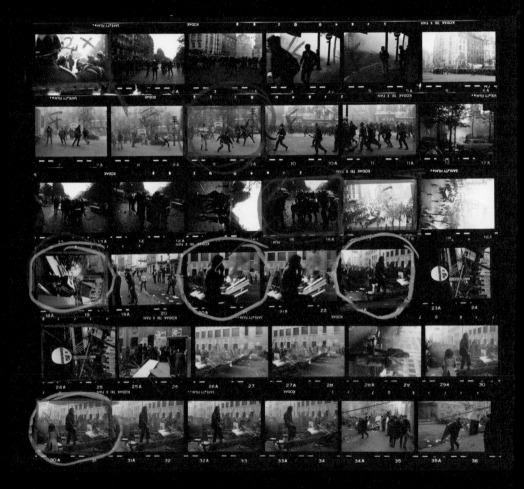

« MUCH ADO FOR NOTHING »

France is uneasy about May 1968. This is both because the events are still difficult to understand and because they have left a sort of embarrassment in their wake on our collective memory. As a people, we are not very proud of it. One has only to consider the debacle that ensued when the question of how to commemorate the events of May 1968 was raised after the election of Emmanuel Macron to the French presidency in the spring of 2017 - the whole issue just fizzled out.

It's certainly not because of any lack of literature regarding this episode in history, on the contrary. Still, curiously, none of these works has truly provided a decisive perspective of the event. Today, we are still asking ourselves whether May 1968 was a bizarre psychodrama, a vast democratic insurrection, or a botched revolution. In truth, the contradictions between these varied interpretations spring from an incredible error in the French state's understanding during this period. It is conventional wisdom to say that May 1968 did indeed take the government of the time by surprise, and not only the government, but public opinion. That much is indeed true. Those of us who were in their forties in May 1968 can attest to that

much – they never saw it coming. Nevertheless, preceding events were harbingers of what would come to pass in the following weeks. In a sense, almost all of what precipitated May 1968 was more or less accomplished before that date; everything that was going to be confirmed and was to materialise during May 1968 was for the most part signalled beforehand. And yet we had no idea then! What do we mean? Namely that this revolution, that brought France into step with the rest of the world after World War II, had already been taking shape for several years before 1968. It was quickly forgotten that this student insurrection took place smack in the midst of the France of the Trente Glorieuses, this industrious and industrial France which was still for the most part largely bourgeois and working class, and undergoing the resurgence of the new middle classes. It was a France proudly cresting on a wave of growth, firmly anchored to a strong, centralising, modernising state. It was a bit too quickly forgotten that, just a few years before, with the demise of French Algeria, de Gaulle had turned the page on our colonial republic through an extensive whitewashing that resulted in profound scars and violent

resentments that surfaced only slowly. In short, it was forgotten that, in May 1968, France was enjoying peace and prosperity. All of society seemed engulfed in a unified march towards modernity, which was in full swing during this era of urbanization, the development of the service sector and mass consumerism, leaving in its wake a myriad of frustrations, the spread of commonplace banality, and an overall lack of high ideals.

All this goes to say that, if there was indeed a revolution, it began well before 1968. It was calm, peaceful, and lasted for a few more years. May 1968 was merely a concomitant event, an unexpected postscript which provided colour to a chapter of history that was in the process of being written. This is the context in which we will evoke this event, fifty years later, one which, despite its ancillary character, remains fascinating due to its dramatic nature.

While we're evoking theatre, let us set the stage. Who were the actors? May 1968 was the existential theatre of a new generation of French youth. This is what remains in the imagination, to the point that one cannot but be astonished by the uproar that began in the form of a spectacular revolt and ended with the electoral triumph of the Conservative party in June, all of which occurred within the space of a few weeks. The France of 1968 was a demographically

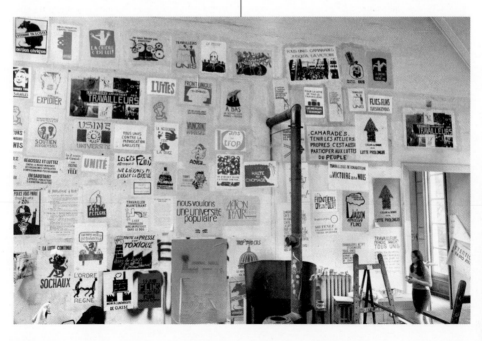

young country, incredibly so. Fifty years later, we have forgotten what a country of young people can be like. Almost a third of all French citizens were less than twenty years old, at a time when the legal coming of age was still set at twenty-one. At the time, the French population was made up of almost eight million youths aged between sixteen and twenty-four. The France of May 1968 was an old country that depended upon its youth. So, what did these youths who irreverently chanted, "Adieu de Gaulle! Adieu de Gaulle!" as they refused to listen to the latter's determined speech on May 24th at the height of the crisis, just what did these youths really want? This question would continue to haunt the old general. For him, this was a "crisis of civilisation". Even de Gaulle was already abusing this term. Was it more of a revolution? Just a letting off of steam? Or a psychodrama, as Raymond Aron dubbed it in retrospect? And yet, the term is in some ways justified. It was a protest that took the form of total chaos. The insurgents of May 1968 were hardly ready to take over the country. Indeed, they were not ready to take any form of political responsibility. At the outset, their initial ambition, both insolent and insouciant, was to claim the right of adolescents to challenge everything. They were – to borrow a psychological and literary term that sums up the truth and spontaneity of the event well – the mood of the country. It was one of a confused desire for liberation and emancipation which had brought the ideological context of the times into being (leftism, "Third Worldism", colonial and cold wars, etc.). It was normal, even part of universal tradition, that the young, particularly students, should be at the forefront of this discontent and that they would be its spokespeople. Likewise, it should not be surprising that, in the France of the time, the forces behind the political undercurrents that had been developing over the course of the Fourth Republic would quickly seize the occasion to associate themselves with the student unrest with the secret intent of channelling it and thus deriving a strategic benefit from it. It was the same assessment which, in the weeks that followed the beginning of the movement, occurred to the political left, then to the unions. On the other hand, one should not forget to number among this diverse and improvised cohort a number of people in the country who, from the first days, did not quite demonstrate active support for the movement but who nevertheless felt a certain affinity for this surge of youthful spirit which was perceived as harmless, spontaneous and generous. This sentiment came for the most part from free-thinkers and those with libertarian sympathies, such as intellectuals, teachers, artists, students who weren't protesting actively, those from the liberated right or left – in short a population whose profile could be defined as the readership of magazines such as *Combat*.

So, on one fine spring day in 1968, France rose up. France? What a charming joke! More like a handful of adolescents, mostly the children of petits bourgeois, socio-culturally, ideologically and geographically. They made up an

OPPOSITE.
Paris, June 15th.
A protester with
a copy of *Combat*
in his pocket at the
funeral of Gilles Tautin,
a student who was
drowned during
a police raid
at the Renault factory
at Flins-sur-Seine
(Yvelines).

PAGE 12. Richelieu
Lecture Hall,
Sorbonne University,
5th arrondissement,
Paris, May 28th. After
a student meeting,
the lecture hall doubles
as a dormitory.

PAGE 17. Sorbonne
University, 5th
arrondissement,
Paris, May 3rd. A
woman reads the
newspaper *France Soir*.
It bears the headline
"Sorbonne
on Lockdown".

PAGE 18. Sorbonne,
5th arrondissement,
Paris, May 14th. The
University courtyard
is covered with graffiti
slogans, this was
one of the most
well-known, "It's
forbidden to forbid."

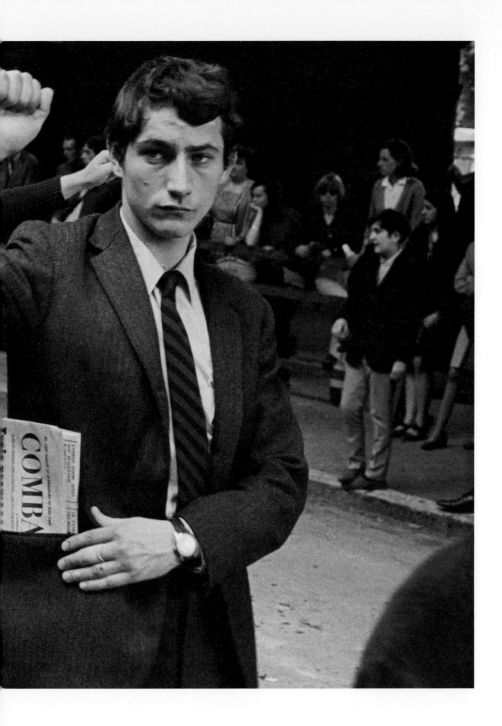

infinitesimal demographic minority, electorally nonexistent, and yet, in a matter of days, they would bring the country to its knees over a marginal cause – youth, and an insignificant incident. What was truly surprising is that the spark did not actually come from the young. The youth of the world had been in turmoil for two decades. They joined together to protest issues such as the Vietnam War, denouncing American imperialism under the banner of the left, the fruit of a convergence between critical Marxism and libertarian aspirations. The revolutionaries changed idols and splintered into rival camps: it was Trotsky vs. Stalin, or Che Guevara and Castro vs. Lenin and Maoist China…

Universities were the incubators of this effervescence throughout the world, from Berkeley to Berlin, Prague to Istanbul, Rome to Tokyo. While May 1968 took on an unforeseen magnitude, it was because, in France, the university was an institution with feet of clay. It was at once hierarchical, fossilised and dispersed into many faculties. The question of the future of youth, which was a concern even at the highest echelons of the State, was concentrated around problems at the university level. Of all Western countries, France had also undergone the most rapid expansion of educational facilities. Between 1958 and 1968, the student population went from 200,000 to 500,000. As early as 1959, as Aron predicted: "Two phenomena are currently creating a profound upheaval in the French nation – the increase in the birth rate and the number of students." He lamented the miserable state of the Sorbonne, and concluded that: "there are a few hundred places in the Sorbonne library, and a few thousand students." Disillusioned, he resigned his position as professor at the Sorbonne a few months prior to May 1968. Nonetheless, the government had not remained inactive. From the inception of the Fifth Republic on November 20, 1963, de Gaulle made a solemn declaration to the French Cabinet: "It is necessary that students be directed towards paths that will open onto avenues, not dead ends." Orientation and selective entrance: the terms of the debate around this unavoidable question for universities had been established a long time ago and the debate continues today. At the beginning of the 1967 academic year, the government began a reform aimed at establishing selective entry into universities. "Selection", the taboo, became a reality. The powder keg was ready and the catalyst was Nanterre.

In 1962, it was decided to establish a university on the outskirts of Paris in order to relieve the overcrowding at the Sorbonne. The area chosen was the most unprepossessing one could imagine, at the heart of a bleak slum area. The SNCF railway station that served the area was called "La Folie–Nanterre". A sign of things to come? The place quickly became a laboratory for the new university which brought together the masters of thought of 1968, from Alain Touraine to Henri Lefebvre. Out of the 11,000 students of the university, a cadre of 130 militants from the far left would topple the status quo. As

Alexis de Tocqueville reminisced about the Revolution of 1848: "It is usually the youth of Paris who engage in revolutions, and they generally do so with the carefree abandon of students going on vacation." That is how it all began at Nanterre. The event that sparked the powder keg was the commotion that ensued when the Minister of Youth and Sport came to inaugurate the pool at the student dorms on January 8, 1968. On that day, there surged forth, like a diabolical genie from a bottle, a mischievous libertarian agitator, then a sociology student – Daniel Cohn-Bendit, born in Montauban in 1945, but of German nationality. A symbol in himself. He verbally confronted the Minister, François Missoffe: "I read your *Livre Blanc sur la Jeunesse* ("White Paper on Youth") and you don't even mention the sexual problems of young people!" thus unleashing a scandal. When the minister retorted that he should use the new pool to cool his ardour, Cohn-Bendit countered, "An answer worthy of Hitler!" The stage was set. This now notorious "White Paper", whose aim was to set out the needs and aspirations of youth at the time, was part of a vast governmental communications campaign. It was a fiasco. Throughout 1967, the internal rule that prohibited contact between male and female students in faculty dormitories was boycotted. Why did the events in Nanterre take on such significance? Overwhelmed and exhausted, the dean, Pierre Grappin, a scholar of German and former member of the Resistance, had done everything possible to ensure the success of the utopian new university at Nanterre. After a strike in November 1967, he had even accepted that the organization of teaching be "co-managed" with the students. However, faced with the consistent agitation orchestrated by around a hundred militants, he could not manage to keep his faculty – where tensions were surging to boiling point – operational. Grappin remains the symbol of this generation gap between the world of the R of yesteryear and that of the new libertarian youth. On January 26, 1968, interrupted and insulted as he was attempting to teach his class, he finally resigned himself to calling in the police to a storm of students chanting:

Valsons la Grappignole /
Flics en civil, murs en béton!
[Let's dance the Grappignole! Cops in plain clothes, and concrete walls!"]

On February 14, Valentine's Day, there was a "residents strike", with vandalism and violence, both at Nanterre and in student housing in universities throughout France. The issue of the freedom to circulate in the boys' and girls' dormitories became a way for the leaders to rally less politicised students. The politicians. hesitated to take control of the internal regulation of academic communities. Proof that revolt pays off…

Then came March 22. Cohn-Bendit managed to assemble 600 students in an amphitheatre on a minor pretext. He harangued and captivated the audience, who had come in search of some sort of spectacular action. He suggested occupying the administrative building and declaring a

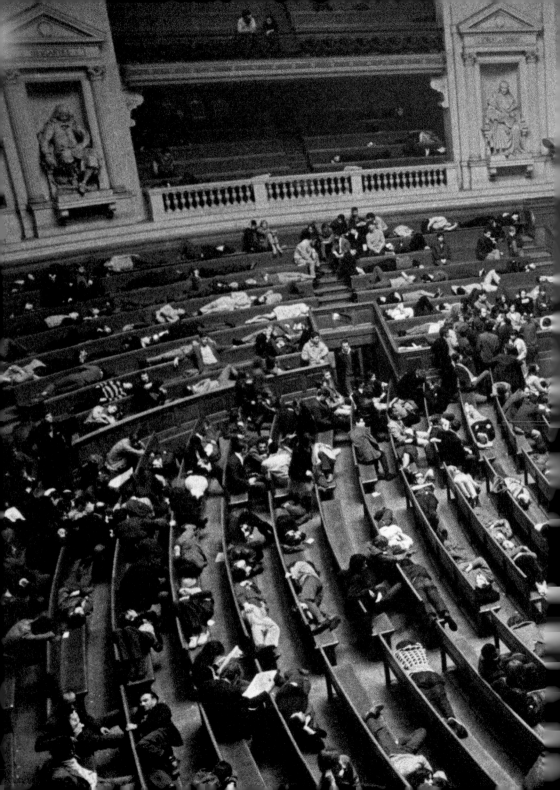

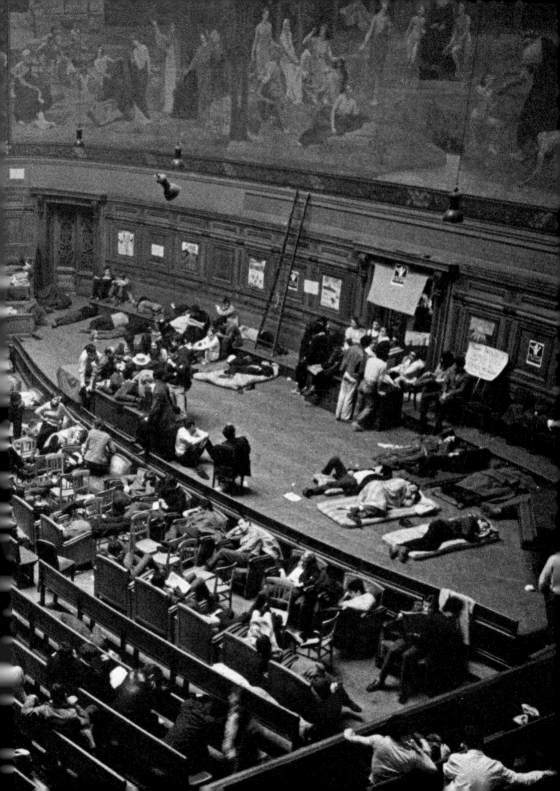

takeover by the students. That evening, everything was brought into question: capitalism and communism, the university and society itself... The "Movement of March 22" was born in the Council Room at Nanterre in tribute to Fidel Castro's "Movement of July 26". The clash had started and was going to spread, as Aron would say. Michel de Certeau, in the Jesuit review *Études*, marvelled: "They spoke out in much the same way as those that took the Bastille in 1789." Behind the scenes of these altercations, the methodical and organised unrest was gaining ground. Dean Pierre Grappin, who had completely lost control, resigned himself to suspending classes on March 28th. As he stated to the Minister of Education: "We have passed the phase of protest. We are at the stage of pre-revolution..." The first closing of Nanterre was brief, but it served as a dress rehearsal and the unrest spread to the Sorbonne. On April 1, a Nanterre cleared of its graffiti was reopening. It was spring break. A *modus vivendi* was found between the "wild ones" and the administration. Grappin was hopeful. However, the graffiti, whose slogans were the hallmark of May 1968, quickly reappeared. Incidents occurred daily: the interruption of classes, altercations, protests, and the boycotting of exams. The Nanterre libertarians, from a college without union traditions, put their stamp on the mise en scène and the style of provocation. One thing was certain: a doctrinaire Trotskyism would not have been enough to lend such an impetus to the movement.

"I have major problems with a redhead," declared Alain Peyrefitte on April 1, during a dinner at the home of Wladimir d'Ormesson, and his nightmares were just beginning. It might have been possible for example to get rid of Daniel Cohn-Bendit. He had been in the sights of the State since January 8, 1968. The Minister of Education had clearly perceived the Nanterre leader's capacity as a public nuisance. As he put it: "The only way to act is to strike at the head. Cohn-Bendit is the head." The hooligan was threatened with expulsion. He made amends and was pardoned. Those at the head of the government had a poor understanding of what was really going on. Also, they were used to this climate of anxiety. The university continued to be a powder keg. In France today, the general perception prevails that the system of government imposed by de Gaulle was authoritarian. It certainly was in terms of its public declarations, but less than one might think in its applications. One must remember that the social vibes of the time were easily troubled, as was the political climate. Also, since the legislative elections of 1967, the conservatives were governing with a mere one vote majority. In short, it has been said enough that a little more attention and a bit less casualness on the part of the public powers would have avoided any degeneration of the movement, which, strictly speaking, was not one. On April 27, Pompidou demanded: "What are we waiting for to deport Cohn-Bendit?" Undoubtedly the extradition of the "elusive redhead" would have changed the

course of May 1968. But it was too late. It was necessary to go through a long and complicated set of university procedures before proceeding to an extradition, and Alain Peyrefitte had not been able to obtain the backing of Fouchet, the Minister of the Interior. Moreover, Cohn-Bendit's appearance before the disciplinary council was set for May 6. The excrement had already hit the fan.

The profile of the personalities involved in May 1968 in France, as well as the ponderous nature of the structures of political power, were determining factors in the sequence of events. Things would never have gotten so complicated if the distinction of the jurisdictions between the university and public powers had not been so vague in matters of policing.

Alain Peyrefitte came up against the ancient traditions of "university exemptions". But the divisions within the heart of the government were no less important. There were two lines drawn within the corridors of power: one, intransigent, regarding the question of order, held by General de Gaulle himself, and also defended by the Minister of Education. The other, more accommodating, was personified by Georges Pompidou, Christian Fouchet, the Minister of the Interior, who was a former Minister of Education, the Garde des Sceaux (Lord Chancellor) Louis Joxe, and the Préfet de Police (Chief Constable) of Paris, Michel Grimaud, who did not wish to see blood in the streets.

At the same time, the divide was not all that well defined: de Gaulle himself, a military man

naturally attached to the maintenance of order, who reminded Fouchet that a Minister of the Interior must also know how to give the order to fire, did not himself even impose the use of force. The head of state was concerned about the future of youth, even as he saw the need to channel it as an authoritarian necessity. "But what does this Cohn-Bendit have going for him?" he demanded of his Education Minister on May 5. The reply: "He has a great talent. He can be in turns playful and off-hand, and yet position himself as the exterminating angel of bourgeois structures... he's a fun-loving anarchist revolutionary." After much prevarication and procrastination, the powers that be had come up with a plan of action: they would deport Cohn-Bendit, clean up the "Casbah", the nickname Peyrefitte had given to Nanterre, and finally, reform the university. But the moment had passed. And so, the famous month of May began.

At the end of April, there was civil agitation everywhere, but the gears had not yet completely engaged. On May 2nd, the Prime Minister, on the point of leaving for a ten-day official visit to Iran and Afghanistan, was confident. As Pompidou declared to his ministers: "We have never been in such a good situation: no motions of censure, no social agitation." Then to Peyrefitte, "with the exception of your fanatics at Nanterre." But the situation seemed well in hand, on the condition that the university authorities not "chicken out."

Did the government really have things in hand? The strategy of escalation and harass-

ment that the "fanatics" had implemented bore its fruit as the students of the Movement of March 22 physically challenged René Rémond. Grappin, the Dean, again had his back up against the wall: he once again suspended courses "until further notice…" The authorities make their appearance. Victory! The Nanterre students extend their action to the Sorbonne. The die is cast.

The rest is well-known. On May 3rd, a meeting of solidarity with Nanterre was organised in the courtyard of the Sorbonne. Three hundred students showed up and the event unfolded within established rituals. Then a rumour began to spread: militants from the far-right Occident movement were going to march on the Sorbonne. Brandished fists and fights between the "reds" and the "fascist pigs" – another national ritual. However, that day, it did not come to pass. Nevertheless, the Rector of the University of Paris, Jean Roche, decided on a preemptive strike: he called in the police and closed down the Sorbonne. Without intending to, he actually provided the spark to ignite the powder keg. Spilling out from the universities, the student movement suddenly flowed out onto the streets of the capital. It was the first week of May. In the midst of spring, confrontations in the street between police and protesters erupted in the heart of the Latin Quarter, more accustomed to tourists. The level of violence was unprecedented since the end of the Algerian War.

The repression only fanned the flames: over six hundred were seized for questioning, with hearings and prison sentences for the protesters – including four students. The movement had its martyrs. The Trotskyist leaders, Alain Krivine and Alain Geismar, both experienced agitators, felt the winds of revolt rising. On the other side of the barricades, Pompidou's absence reinforced the sense that the State was prevaricating: contradictory injunctions, vacillating between increased firmness and attempts at appeasement, escalated.

The forces of order were also stymied by a vertical mode of communication. The control of the ORTF (Office de Radiodiffusion-Télévision Française) broadcasting system reinforced the impression of a gap in public opinion, which shifted in favour of the student movement. In his diary, Peyrefitte notes this perceptible evolution in public opinion and expresses worry about what he refers to as an "impassioned solidarity". The press stigmatised police violence, while the radio stations that were not a part of the ORTF network saw their audiences climb, since they offered more direct coverage of the events unfolding. Each day saw a new series of protests. On Monday, May 6, with the support of the union organisations and parties of the left, 15,000 people took to the streets. In the evening, more clashes occurred. On Tuesday the 7th, in Paris, it was the "Nuit des Marcheurs" (the night of the marchers): thousands of students occupied the Place de l'Etoile for part of the night, before returning to the Latin Quarter. Another night of violence ensued. The movement was spreading to the cities of

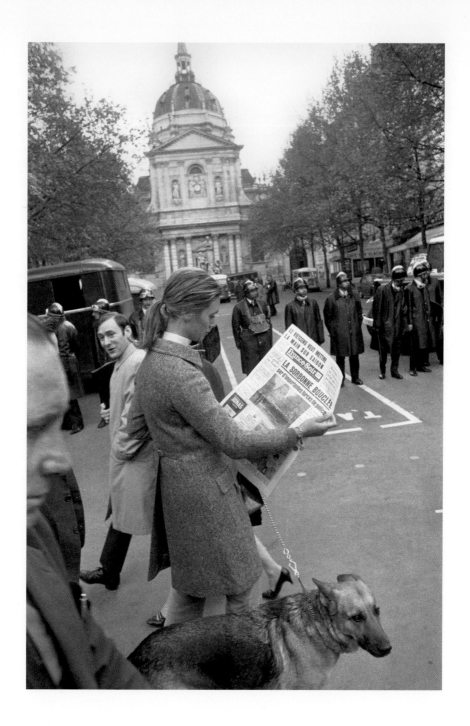

the provinces: Toulouse, Nantes, Lyon, Lille, Bordeaux, Marseille... Everything indicated that the movement defied classic methods of control. From day to day, tensions erupted into violence, as Bruno Barbey's eloquent photos attest. One major symbol of the dilemma that confronted those in power: the question of the reopening of the Sorbonne. Was it a necessary gesture of appeasement or a fatal sign of weakness? After having decided to close the university, the academic authorities essentially found themselves dispossessed of their powers. The affair devolved totally into the hands of the government, and consequently became associated with its authority. As the French cabinet stated on May 8th: "Order shall be maintained." Five Nobel laureates, including François Mauriac, officially requested that the head of the French State make a "gesture to calm the student revolt". de Gaulle dismissed this as "contemptible demagoguery". The Minister of Education evoked the eventual reopening of the Sorbonne before the deputies of the Assemblée Nationale, if certain conditions were met, conditions rejected by student leaders. "The struggle continues!" Attempts at de-escalation came to a sudden stop. Finally, it was Pompidou who, upon his return on May 12, stepped up. He thought he could turn back the clock on the whole affair. But it was too late, and his ges-

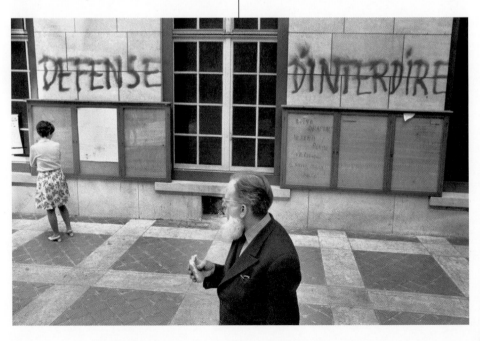

ture looked like one of weakness. In the meantime, everything had changed dramatically during the second "red Friday" in May, during the night of rioting from the 10th to 11th of May, when, after a massive gathering at Place Denfert-Rochereau, Cohn- Bendit ordered the occupation of the Latin Quarter, resulting in the spontaneous erection of around forty barricades along the streets around the Sorbonne by students. An air of revolution floated over Paris. The government attempted to open negotiations with an examination of student demands. Radio Luxembourg broadcasted a minute-by-minute narrative of the situation, even managing to gain access to the offices of the harried rector Jean Roche, who had unknowingly allowed Cohn-Bendit to infiltrate the delegation of professors led by Alain Touraine. In one of the legendary episodes of May 1968, Peyrefitte rings up on Roche's office phone to ask: "Do you happen to have a rather chubby redheaded student in your office?" It showed up the powers that be as overwhelmed and exposed them to ridicule. However, Chief Constable Grimaud would undertake the clean-up of the barricades during that night. No shots were fired but there were violent clashes, and the use, initially denied, of chlorine and phosphorus, left their mark. Pompidou's concessions and the reopening of the Sorbonne on May 13 would not change a thing. The fracture between the country and the government widened. Symbolically, on that day of the general strike, the protester's slogan was "Ten years is enough!" Moreover,

another revolt was surfacing, that of workers. It began in Brittany.

The most singular thing about May 1968 in France was the way the movement spread out throughout society: the widespread strikes, the occupation of factories, leading to a social crisis, and consequently, to a governmental crisis. There again, the government seemed to be caught off guard. The movement spread with lightning speed. As early as May 16th, the Renault factory at Boulogne-Billancourt became involved. The coalescing of union forces with the student movement had happened. From the 18th to the 20th, the strikes spread to the SNCF rail network and the postal service, as well as to thousands of factories throughout the country. On May 23rd, at the height of the movement, almost 7 million French citizens were on strike.

This shifting of the agitation to the social sphere would represent both a threat of civil war as well as a formidable lifeline for the government. It provided a certain materiality to both the demands made and the political threat posed. General de Gaulle's departure on an official visit to Romania enabled the Prime Minister to take things in hand. It was then that Georges Pompidou showed his immense sang-froid and political finesse. He quickly understood that his main allies were actually in the enemy camp: the Communist Party and the CGT trade union. As early as the first days of May, before his departure to Iran, he had delightedly remarked upon this in the presence of Peyrefitte. On the morning of May 3, the Communist daily *l'Humanité*

published an editorial by the head of the Communist Party, George Marchais, entitled: "False Revolutionaries to be Unmasked" in which the author denounced the little groups led by the "German anarchist Cohn-Bendit". He concluded that they must be energetically opposed. Pompidou immediately phoned Peyrefitte to exult that he understood it all, he comprehended what had eluded De Gaulle right up to the end. The root of the matter was understood.

That's all there was to it! Certainly, the events of May were only in their earliest beginnings and the two subsequent weeks were full of events that, on every level, would justify public concern. The student revolt was not fizzling out and the social climate remained tense. The political left thought that its moment had arrived. To add icing to the cake, de Gaulle disappeared for a few hours. It all amounted to so many epiphenomena and illusions since the crisis was well on its way to being resolved as soon as the respective survival instincts of the Conservative right and the Communist left had logically brought the two parties together for the greater advancement of their respective agendas, and undoubtedly also that of the national interest, all of which were, one must admit, paramount over the existential equilibrium of an adolescent student community. It was thus that, under the patronage of the "government of the two Georges" – George Pompidou and Georges Séguy, head of the CGT union – and a cloak of great secrecy, the famed Accords de Grenelle (Grenelle Agreements) were signed on May 27. They did not bring the activities of May 1968 to an immediate halt, but the result was the same: they had locked down the political outcome without the knowledge of the President of the Republic. The most delightful closing comment came from the Communist leader Waldeck Rochet: "the General doesn't have the right to leave." Another moral of this fable to be retained was a very pertinent observation by Georges Pompidou. Before the events of May unfolded, the Prime Minister made a remark that would prove to be intensely perspicacious regarding its denouement. Addressing a group of young Gaullists on March 21, 1968, he stated: "Youth must question everything, and mature men must order everything." All the history of May 1968 is summed up in this maxim, which precisely defines the repercussions of the events, this strange happening that seems a mixture of a hoax, a party, and an illusion, in short, an historical comedy of errors.

OPPOSITE. Sorbonne, 5th arrondissement, Paris, early June. The Principal's Office, now occupied by students.

FOLLOWING PAGES. Boulevard Saint Germain, 6th arrondissement, Paris, May 6th. Battle lines are drawn at the intersection of the Rue du Four.

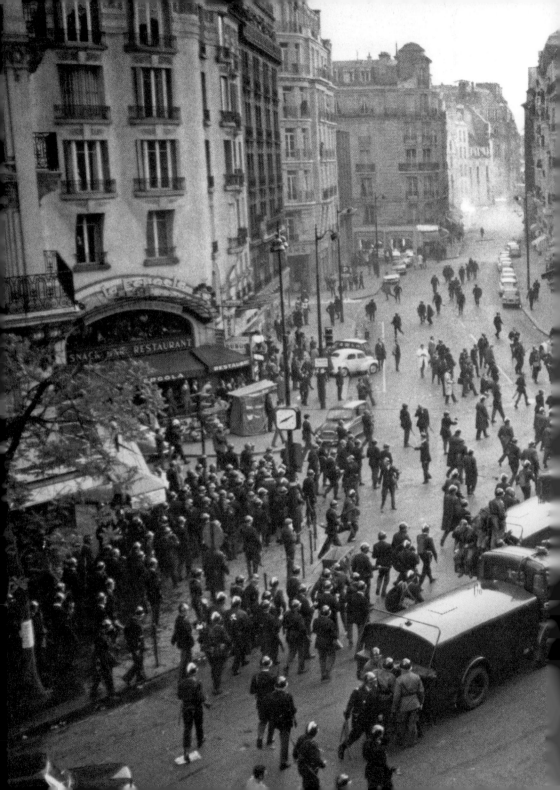

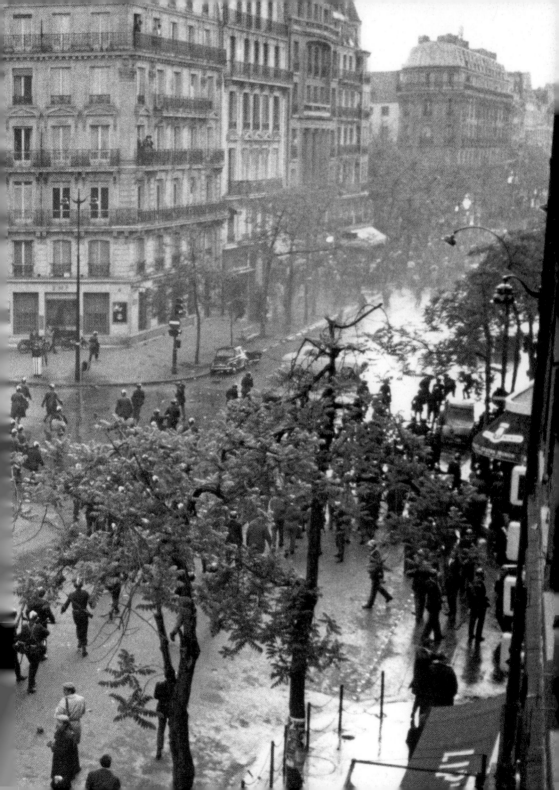

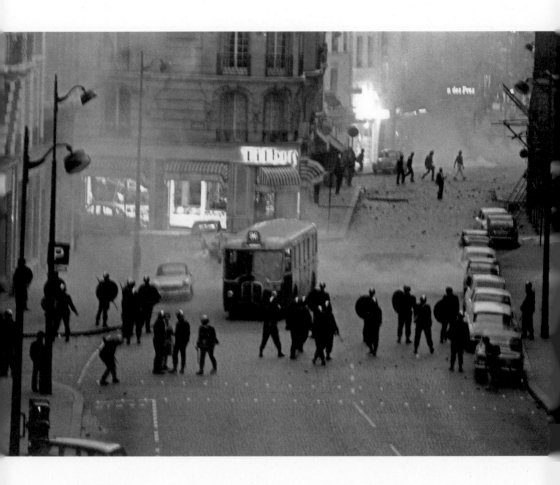

ABOVE. Boulevard Saint Germain, 6th arrondissement, Paris, May 6th. Intersection of the Rue du Four.

OPPOSITE, TOP. Boulevard Saint Germain, 6th arrondissement, Paris, May 6th. CRS riot police.

OPPOSITE, BOTTOM. Boulevard Saint Germain, 6th arrondissement, Paris, May 6th. CRS riot police and a protestor.

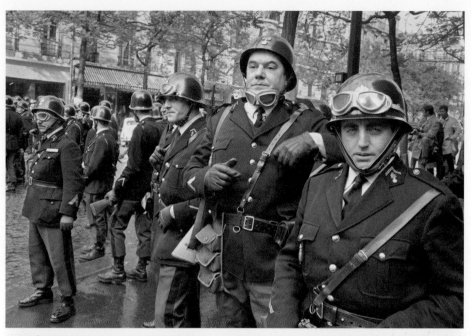

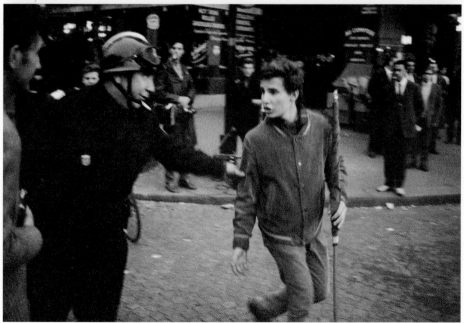

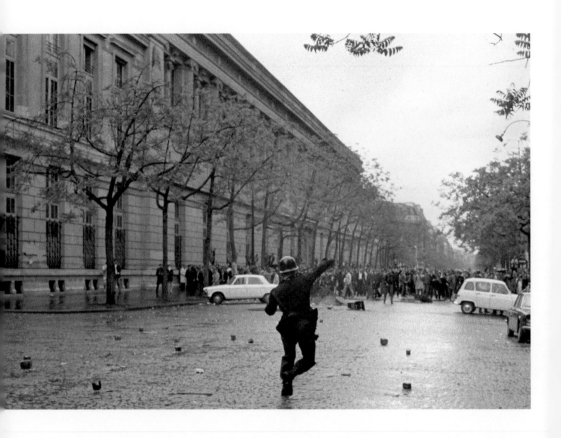

Faculté de Médecine
(Medical College),
Boulevard Saint
Germain, 6th
arrondissement,
Paris, May 6th. CRS
riot police clash with
demonstrators in front
of the university.

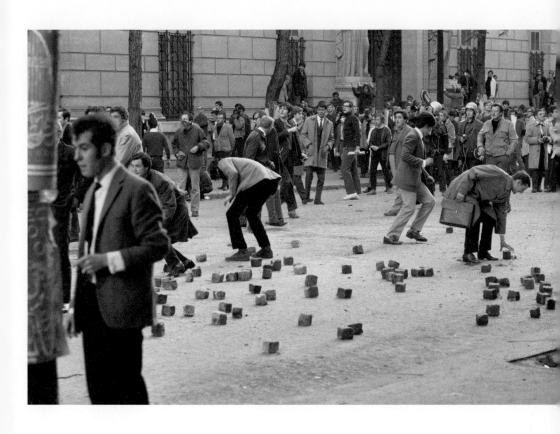

ABOVE. Boulevard Saint Germain, 6th arrondissement, Paris, May 6th. Protesters gather.

FOLLOWING PAGES. Boulevard Saint Germain, 6th arrondissement, Paris, May 6th. CRS riot police at the Mabillon intersection during a charge.

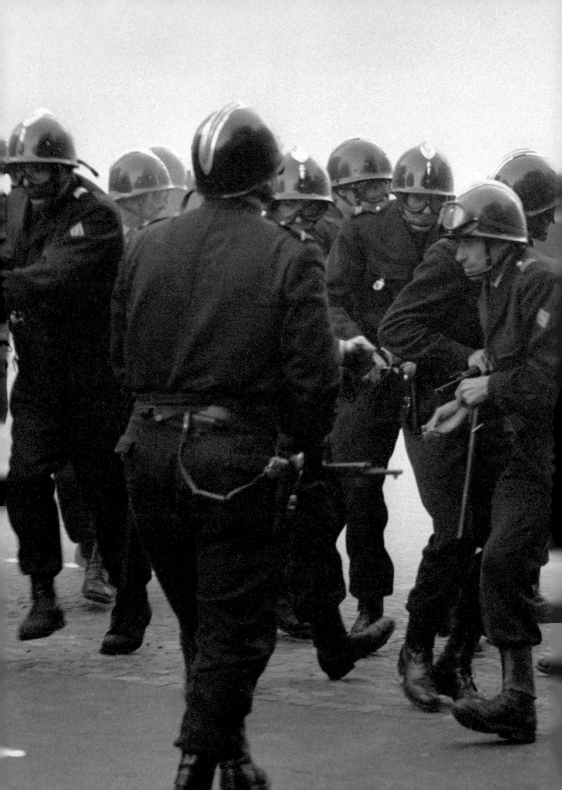

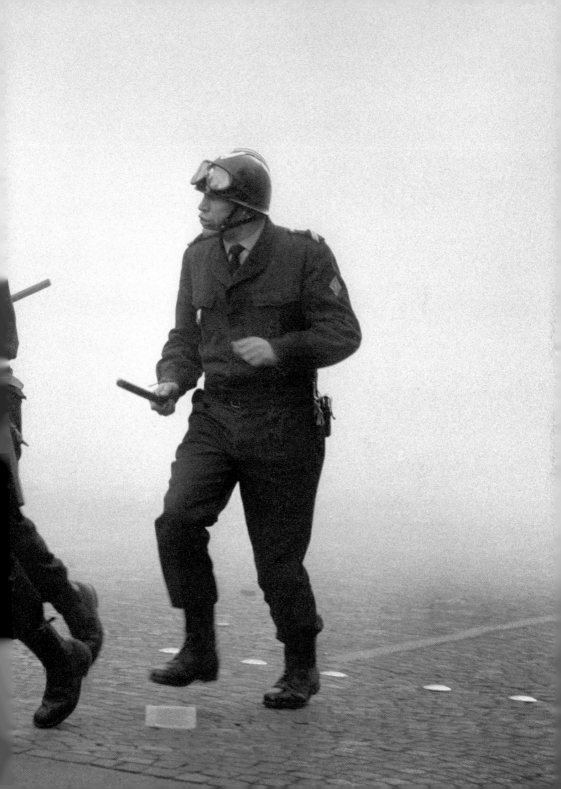

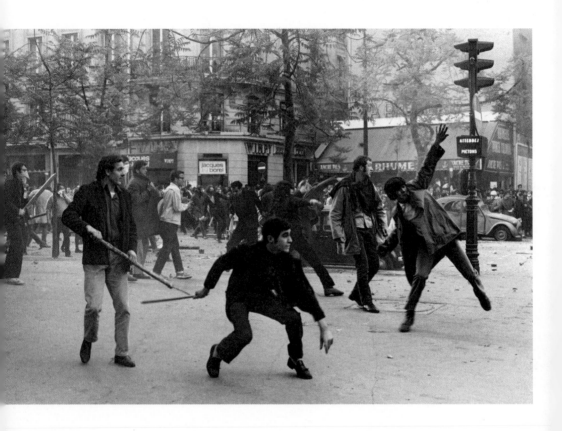

Boulevard Saint
Germain, 6th
arrondissement,
Paris, May 6th.
Students hurl
projectiles at
the police.

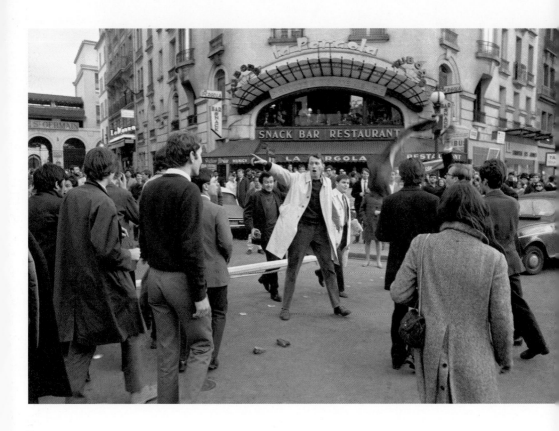

Boulevard Saint
Germain, 6th
arrondissement,
Paris, May 6th.
Demonstrators at
the intersection of
the Rue du Four.

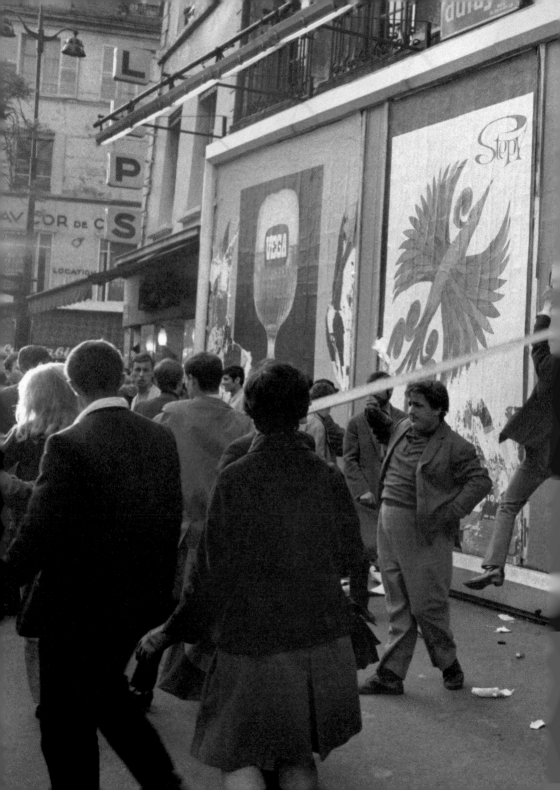

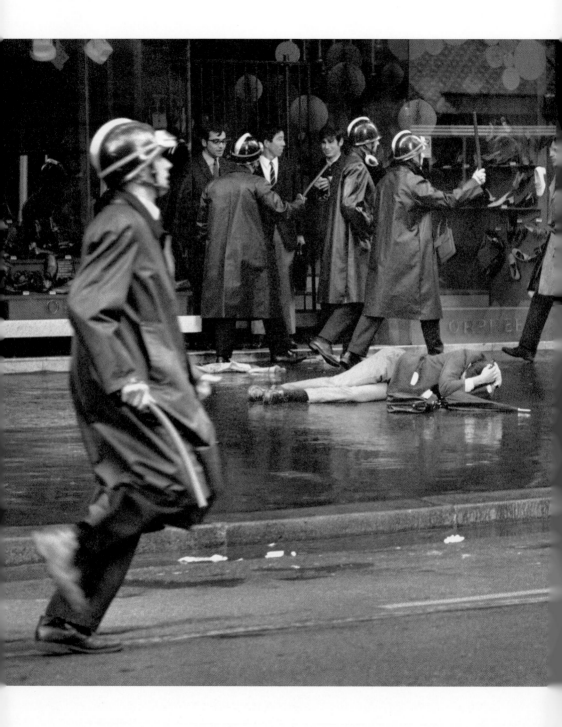

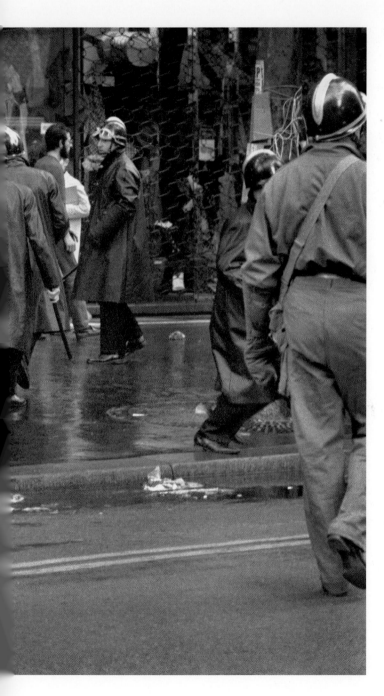

PRECEDING PAGES.
Latin Quarter, 6th
arrondissement, Paris,
May 6th. Protesters
tear up advertisements
in the streets.

OPPOSITE. Latin
Quarter, 6th
arrondissement, Paris,
May 6th. CRS riot
police clash
with protestors
on the Boulevard
Saint Michel.

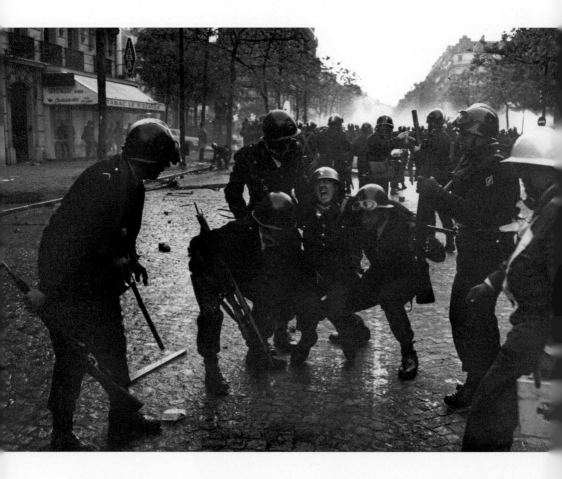

ABOVE. Boulevard Saint Germain, 6th arrondissement, Paris, May 6th. CRS policeman injured after a confrontation with students.

OPPOSITE, TOP. Boulevard Saint Germain, 6th arrondissement, Paris, May 6th. CRS policeman carries an injured comrade on his shoulder after a nighttime clash.

OPPOSITE, BOTTOM. Rue Gay Lussac, 5th arrondissement, Paris, May 10th. CRS riot police charge the barricades.

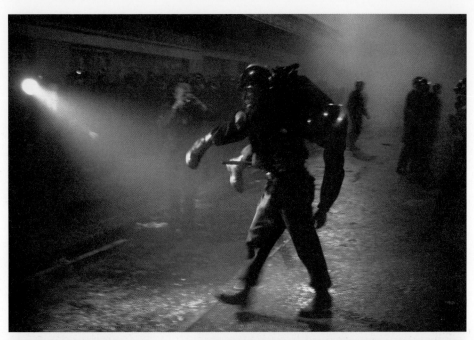

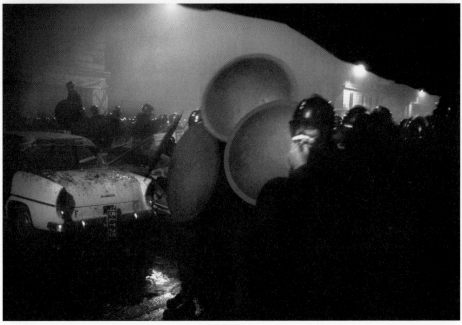

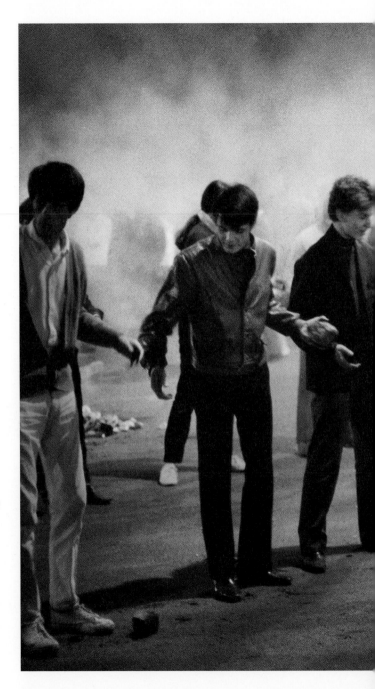

OPPOSITE. Rue Gay Lussac, 5th arrondissement, Paris, May 10th. Students form a human chain to pass cobblestones to build the barricades.

FOLLOWING PAGES. Intersection of Rue Gay Lussac and Rue Saint Jacques, 5th arrondissement, Paris, May 10th. Barricades of cobblestones at the intersection of Rue Gay Lussac and the Rue Saint Jacques.

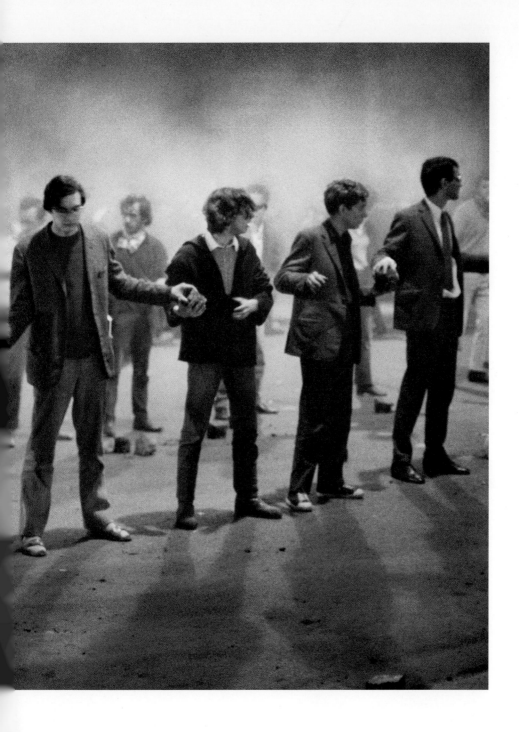

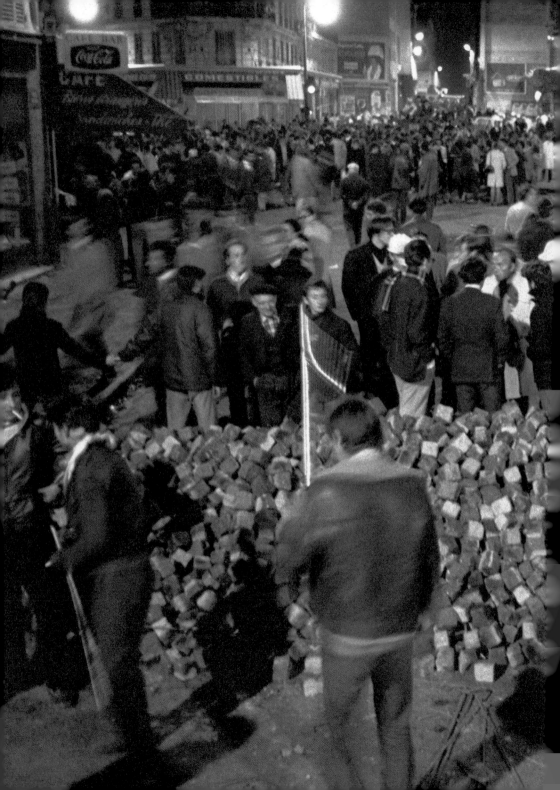

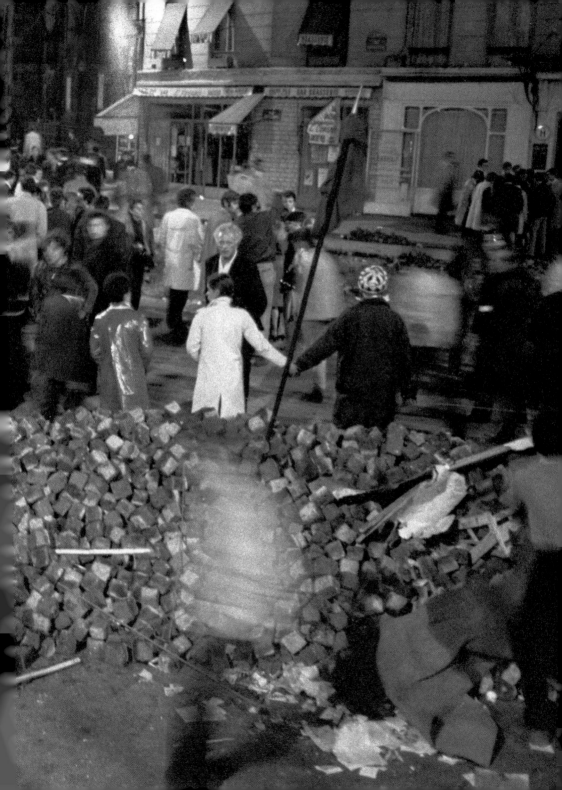

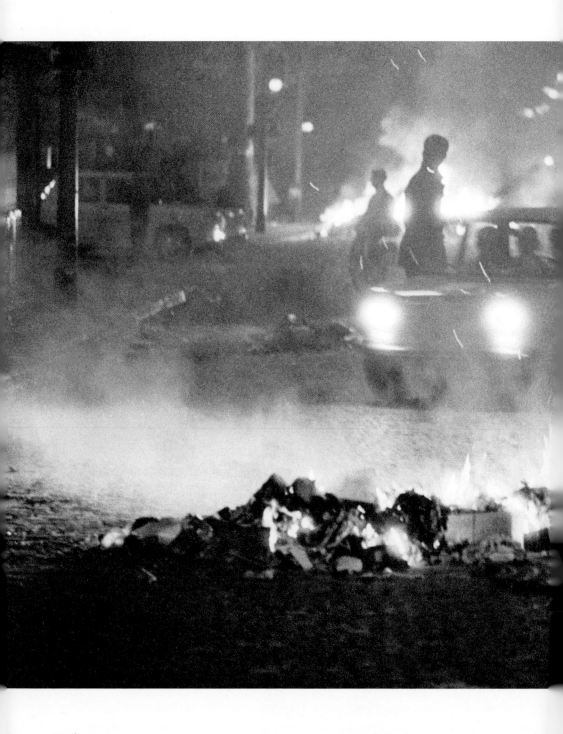

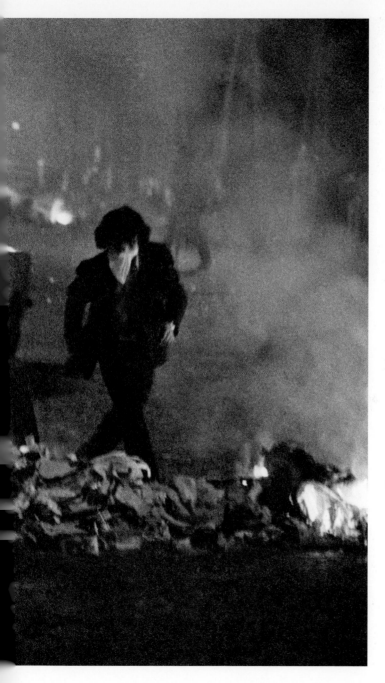

OPPOSITE. Boulevard Saint Michel, 6th arrondissement, Paris, May 10th. Student barricade.

PAGE 44, TOP. Rue Gay Lussac, 5th arrondissement, Paris, May 10th. Cars burning in the street.

PAGE 44, BOTTOM. Boulevard Saint Michel, 6th arrondissement, Paris, night of May 10th-11th. Demonstrations rage through the night.

PAGE 45, TOP. Boulevard Saint Michel, 6th arrondissement, Paris, night of May 10th-11th. Teargas canisters explode on the Boulevard Saint Michel.

PAGE 45, BOTTOM. Boulevard Saint Michel, 6th arrondissement, Paris, night of May 10th-11th. Protesters fight back with Molotov cocktails.

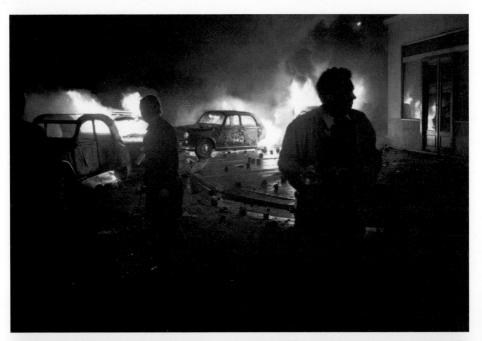

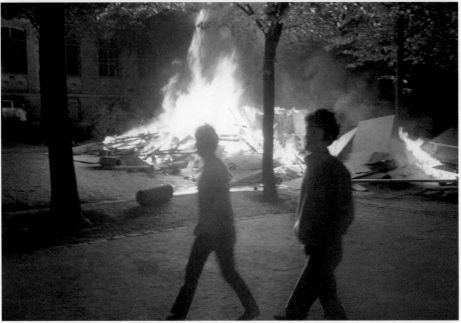

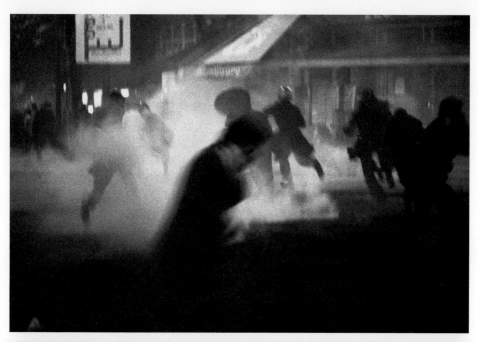

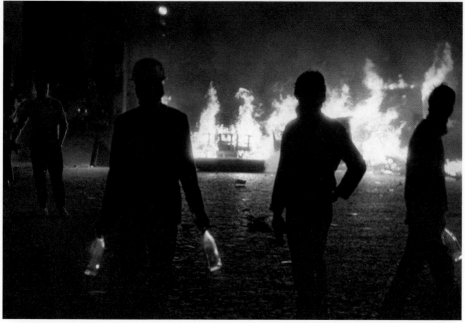

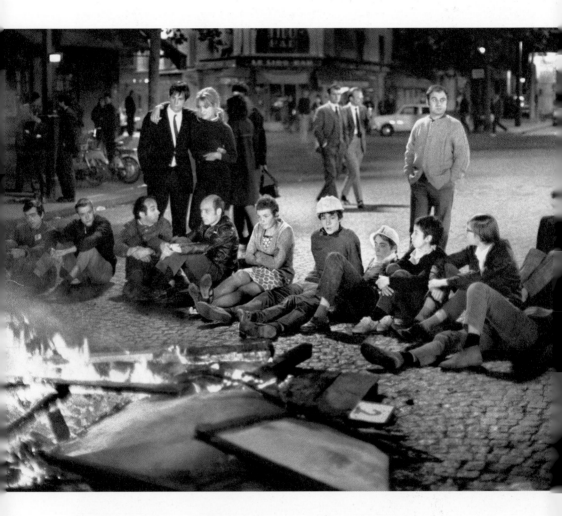

ABOVE. Boulevard Saint Michel, 6th arrondissement, Paris, night of May 10th–11th. Students man the barricades.

OPPOSITE, TOP. 6th arrondissement, Paris, night of May 10th–11th. An injured student is evacuated under the eyes of the CRS riot police.

OPPOSITE, BOTTOM. Latin Quarter, 6th arrondissement, Paris, night of May 10th–11th. Overturned car.

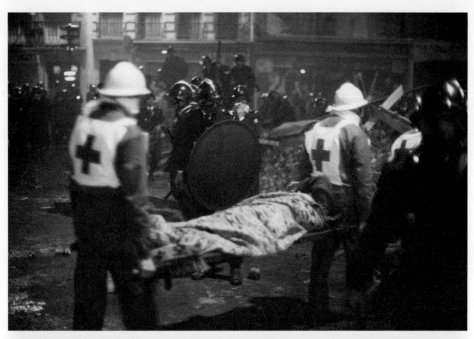

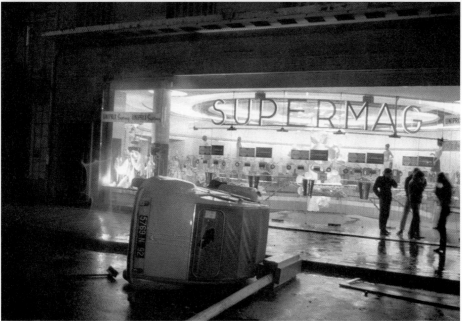

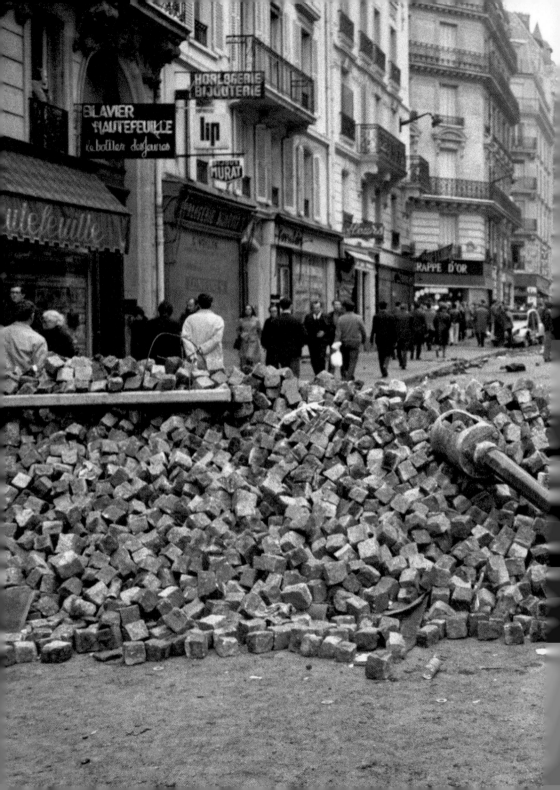

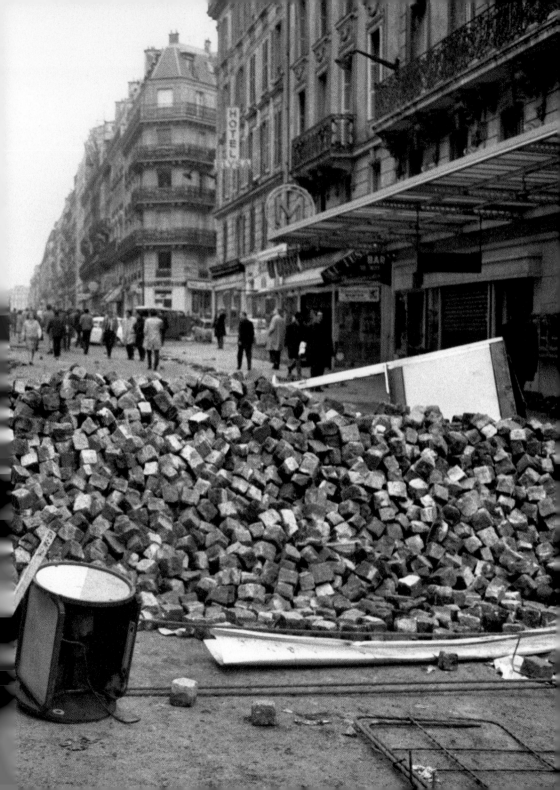

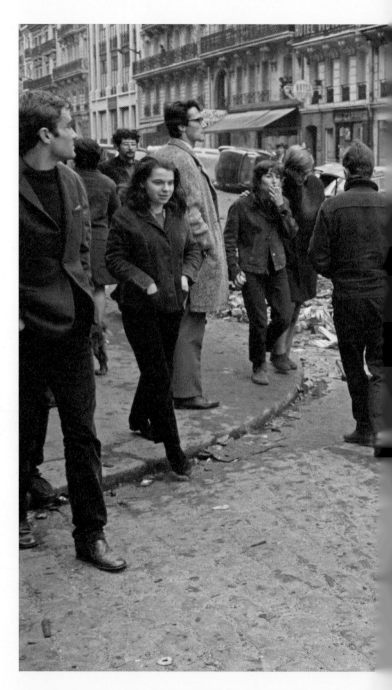

PRECEDING PAGES.
Rue Gay Lussac,
5th arrondissement,
Paris, morning of May
11th. Barricade.

OPPOSITE. Rue
Gay Lussac, 5th
arrondissement, Paris,
morning of May 11th.

PAGE 52, TOP.
Intersection of
Rue Gay Lussac and
Rue Royer Collard,
5th arrondissement,
Paris, morning of May
11th. Cars line the
streets after a night
of rioting.

PAGE 52, BOTTOM.
Rue Gay Lussac,
5th arrondissement,
Paris, morning
of May 11th.
Overturned car.

PAGE 53. Rue
Gay Lussac, 5th
arrondissement, Paris,
morning of May 11th.

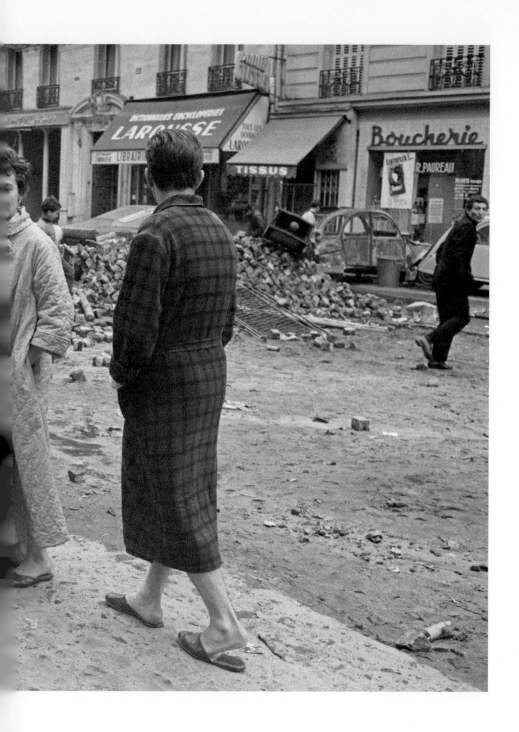

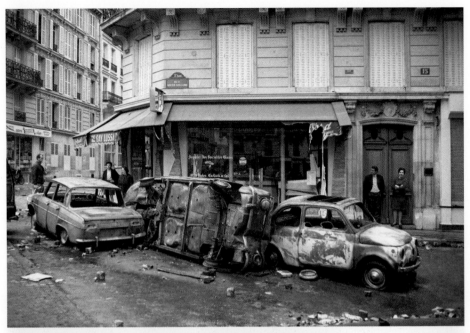

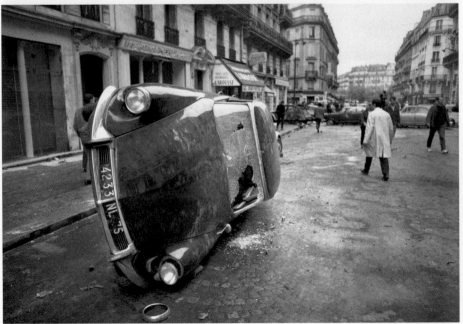

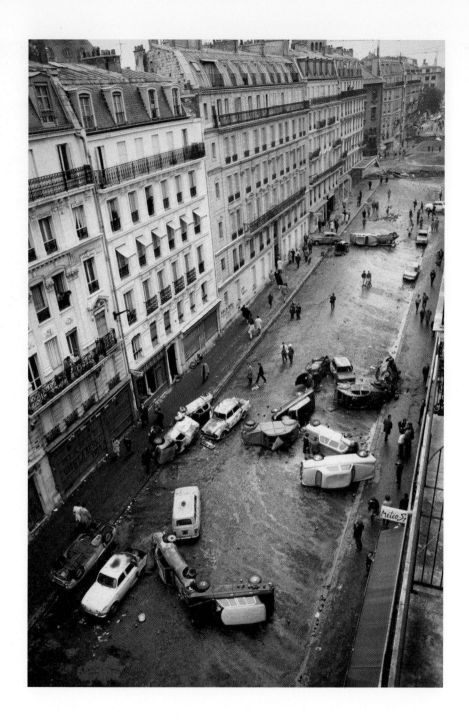

OPPOSITE. Paris, May 13th. Demonstration of around one million workers and students stretches from République to Denfert-Rochereau.

PAGE 56, TOP. Paris, May 13th. Demonstration of around one million workers and students extends from République to Denfert-Rochereau.

PAGE 56, BOTTOM. Paris, May 13th. Film students protest on the Boulevard Raspail before a meeting at the Charléty Stadium.

PAGE 57. 12th arrondissement, Paris. Protestors gather at the Gare de Lyon. The sign reads: "ORTF (French broadcasting service) on strike! Imagination on the air."

PAGE 58. 5th arrondissement, Paris, May 14th. Students occupy the square in front of the Sorbonne.

PAGE 60. Boulogne-Billancourt, May 17th. Student leader Jacques Sauvageot speaks at a nighttime demonstration at the Renault car factory, which was on strike.

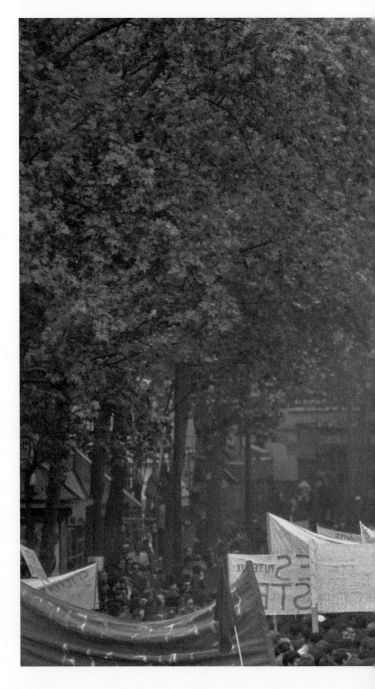

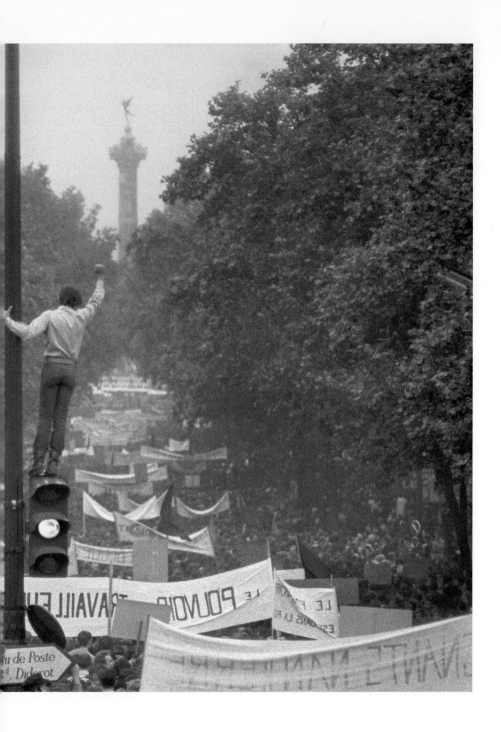

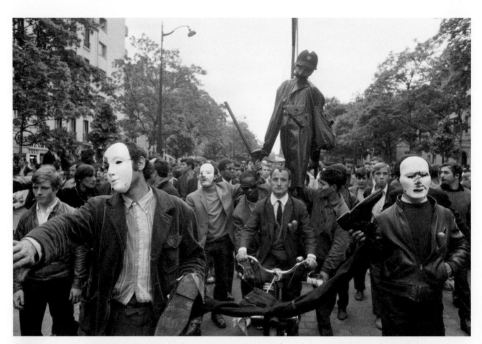

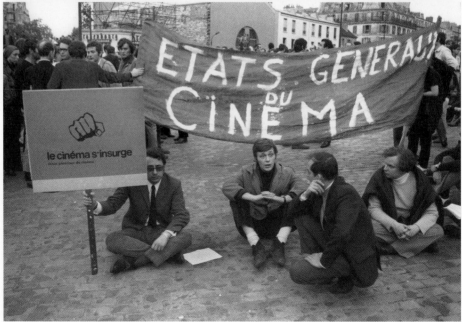

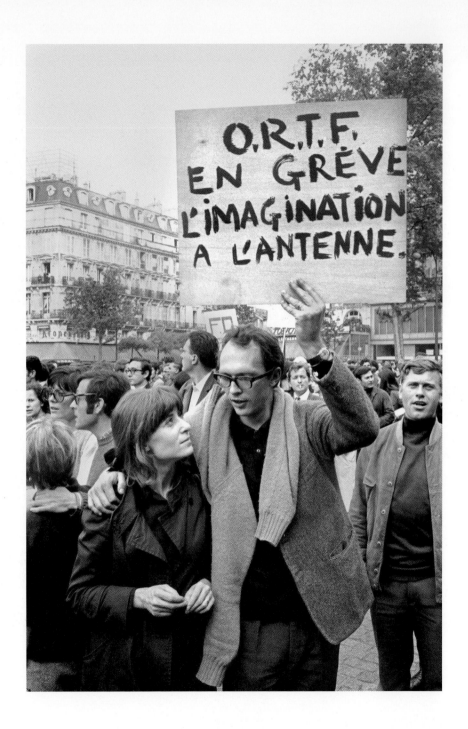

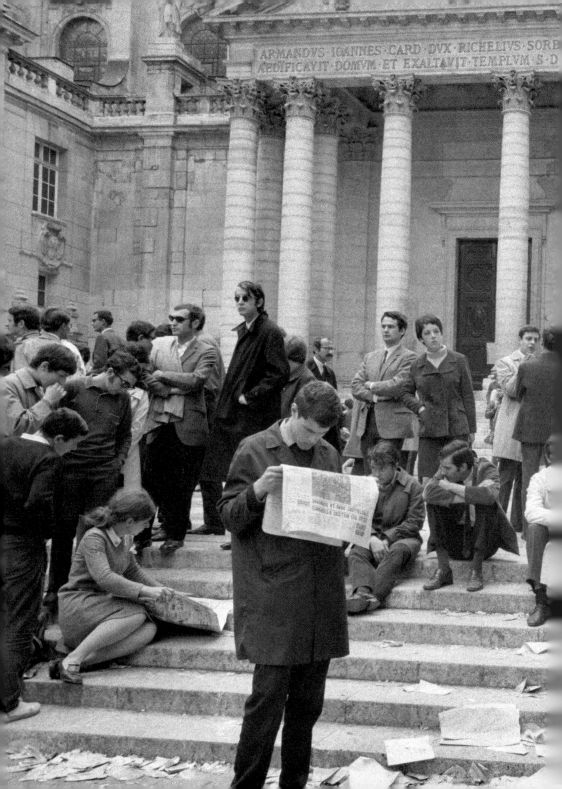

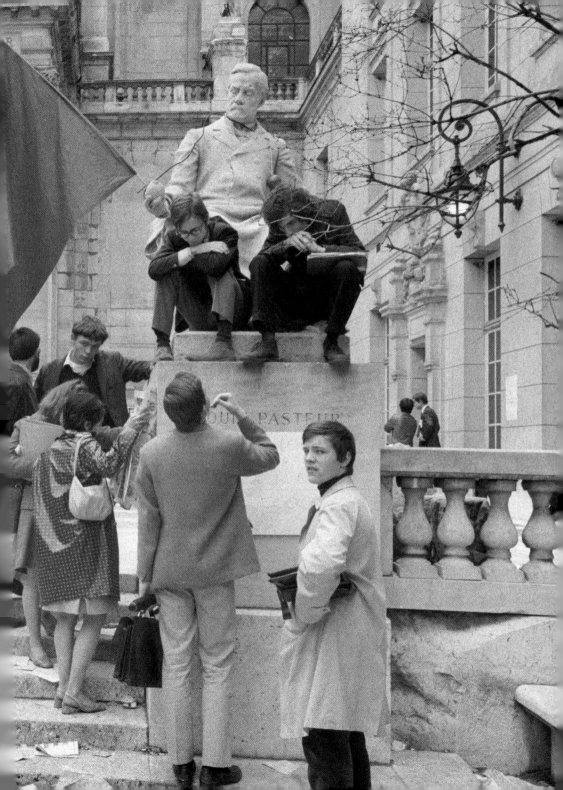

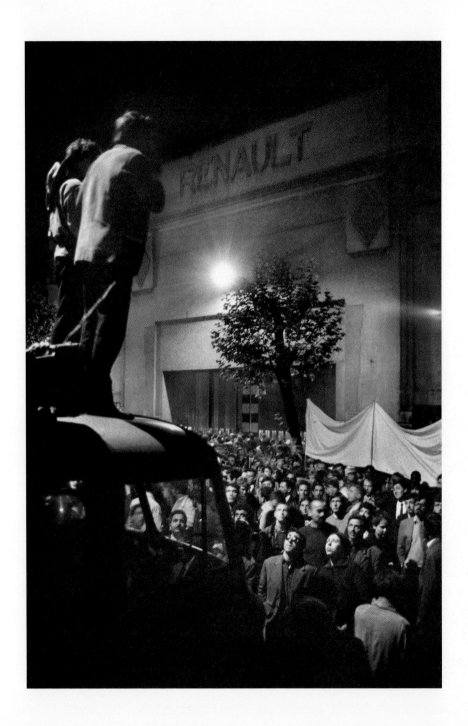

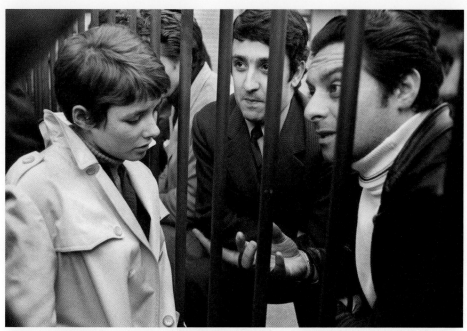

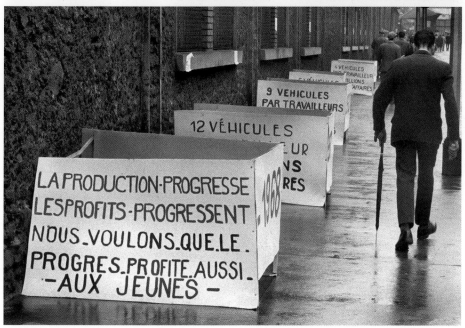

LA PRODUCTION·PROGRESSE
LES PROFITS·PROGRESSENT
NOUS·VOULONS·QUE·LE·
PROGRES·PROFITE·AUSSI·
— AUX JEUNES —

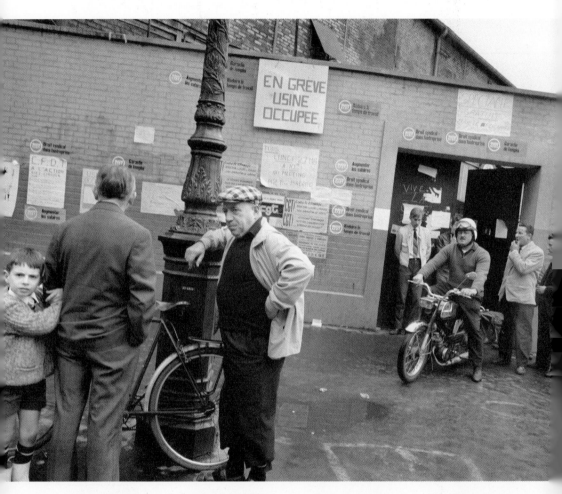

PAGE 61, TOP. Female student talks to striking workers at the Renault car factory in Boulogne-Billancourt (Hauts-de-Seine), May 17th.

PAGE 61, BOTTOM. Boulogne-Billancourt (Hauts-de-Seine), May 17th. Strikers' demands posted at the entrance to the Renault car factory.

ABOVE. Boulogne-Billancourt (Hauts-de-Seine), May 17th. Outside the Renault car factory during the strike; a sign states that the factory is occupied.

OPPOSITE. Boulogne-Billancourt (Hauts-de-Seine), May 17th. An effigy of a factory boss hangs outside the Renault car factory, where signs announce the strike.

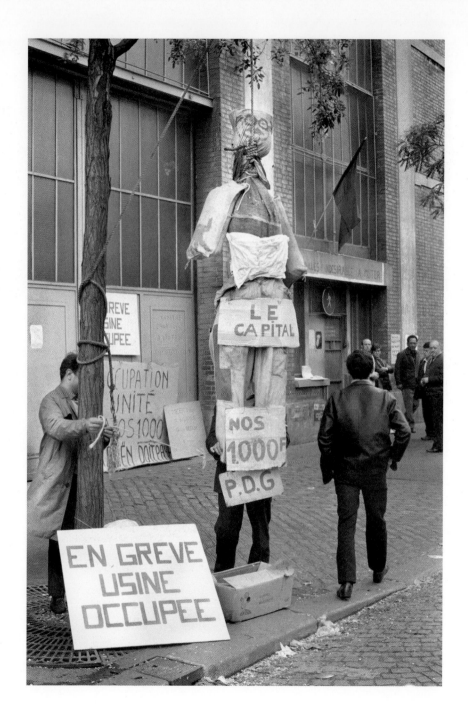

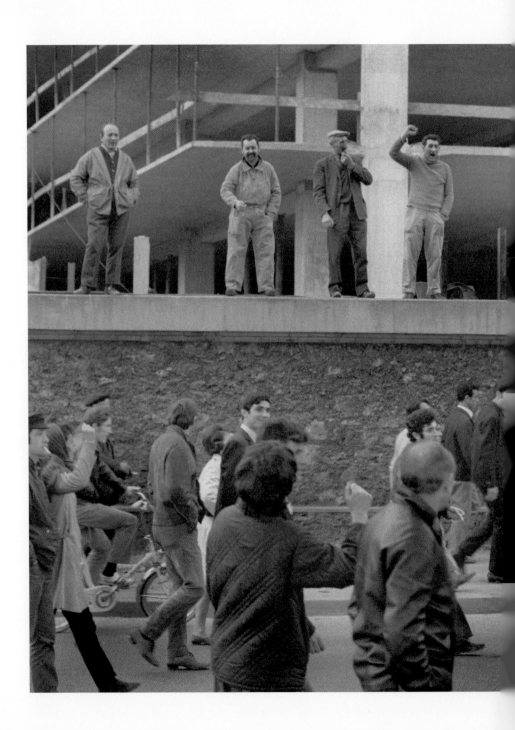

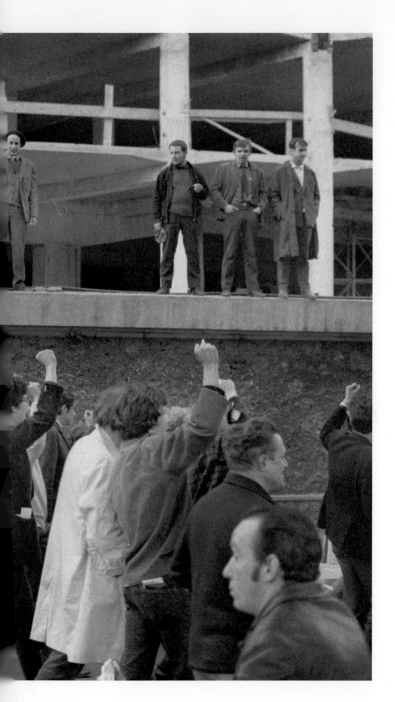

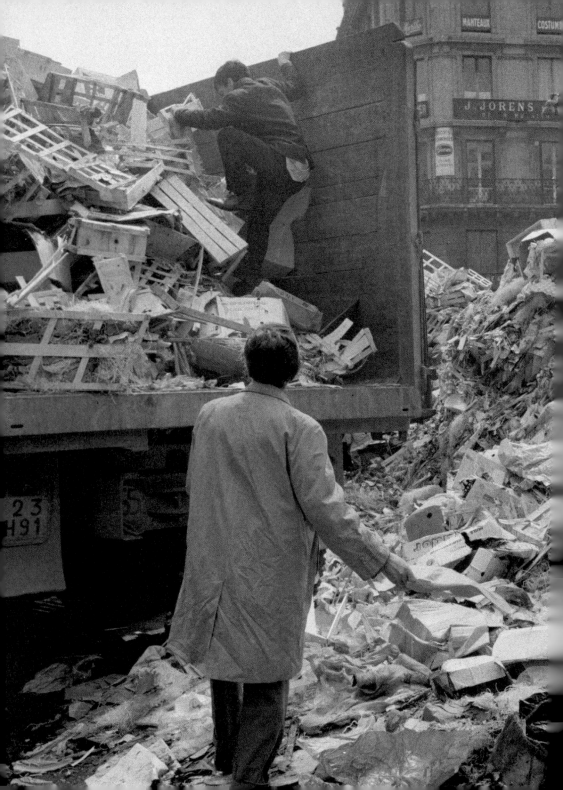

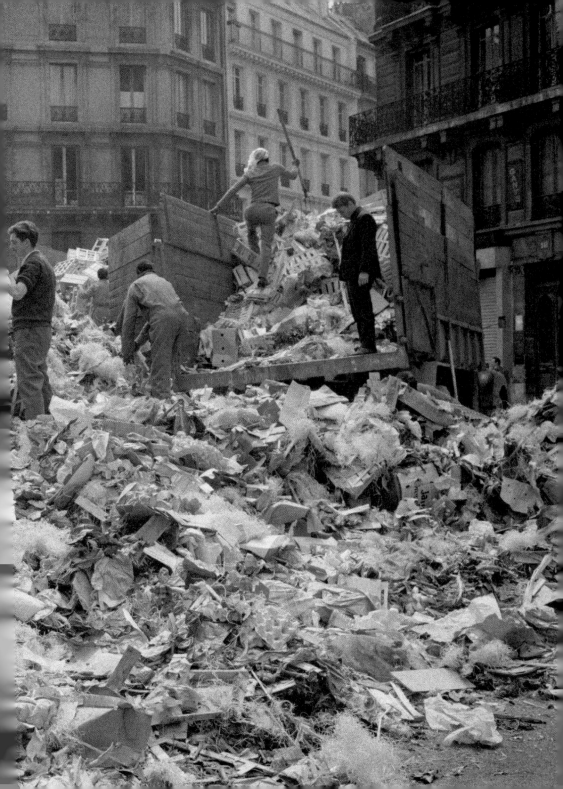

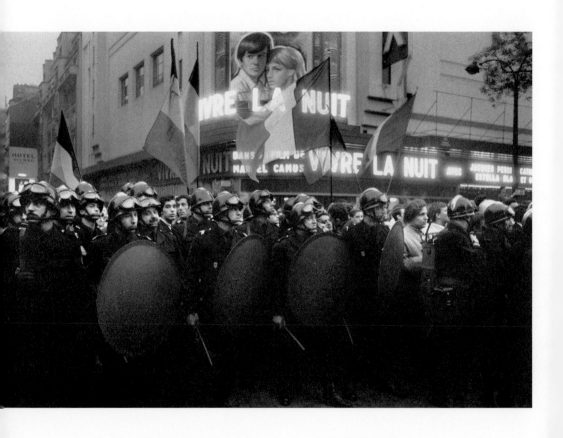

Grands Boulevards,
2nd arrondissement,
Paris, May 24th. Riot
police mass during a
demonstration in front
of Le Rex cinema.

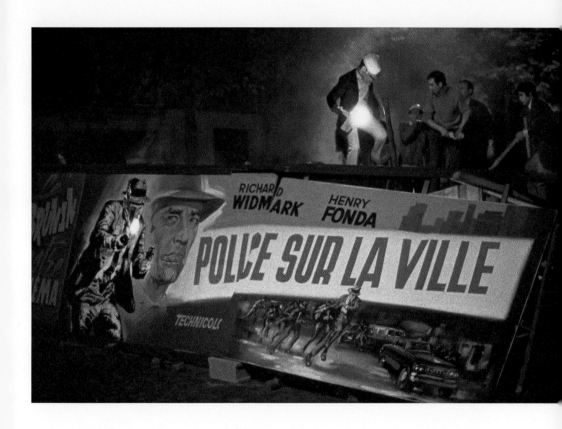

ABOVE. Rue de Lyon, near the Bastille, 12th arrondissement, Paris, May 24th. Barricade that makes clever use of the billboard for the American film *Madigan*, whose title in French is "Police in the City".

PAGE 70, TOP. Charléty Stadium, 13th arrondissement, Paris, May 27th. Workers and students come together at the stadium.

PAGE 70, BOTTOM. Boulevard Raspail, 14th arrondissement, Paris, May 27th. Demonstration before the meeting at Charléty Stadium. In the centre, Jacques Sauvageot, one of the student leaders.

PAGE 71. Charléty Stadium, 13th arrondissement, Paris, May 27th. Assembly of workers and students at Charléty Stadium.

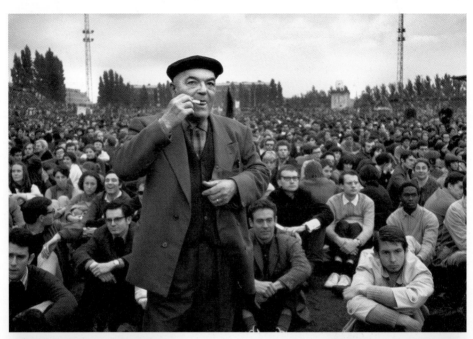

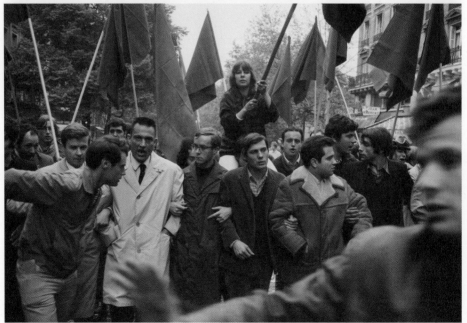

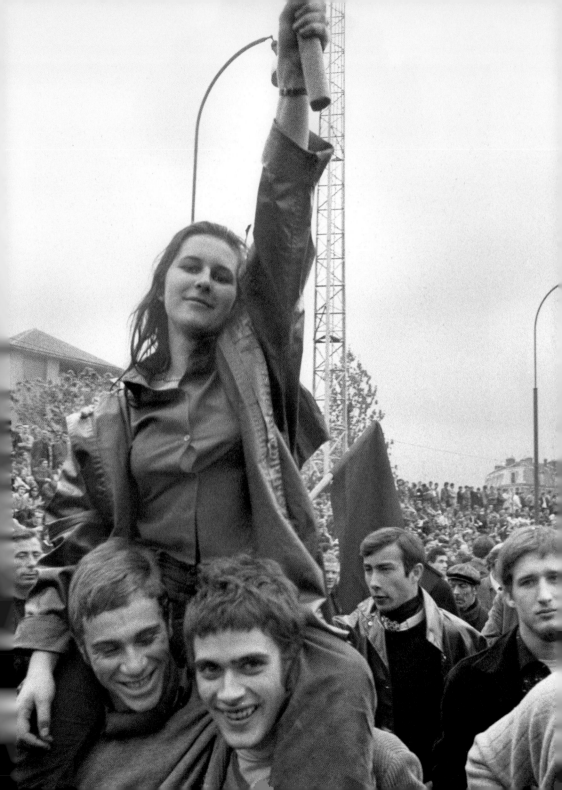

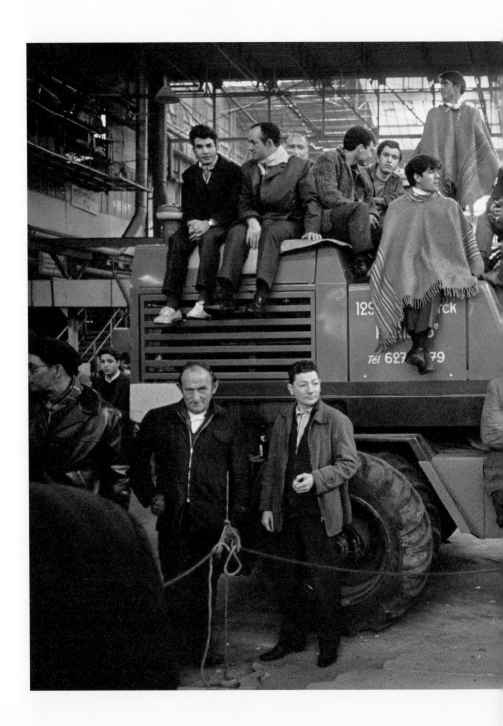

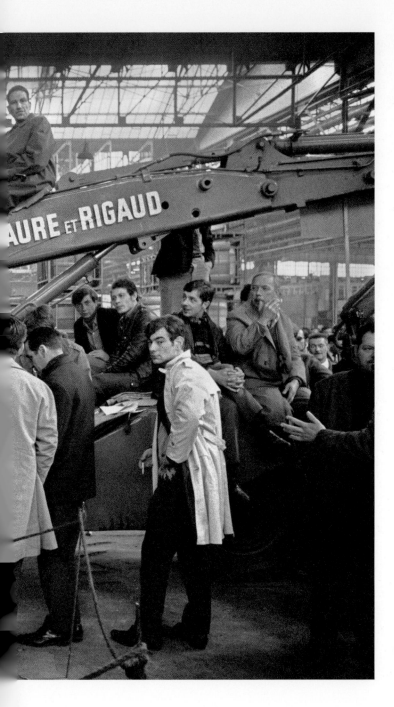

Boulogne-Billancourt, Hauts-de-Seine, May 27th. Meeting of the CGT (French trade union) at the Renault car factory during their strike. Strikers have gathered to listen to reports on the Grenelle Agreements (Accords de Grenelle).

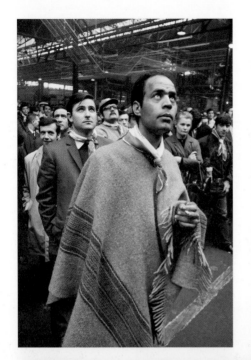
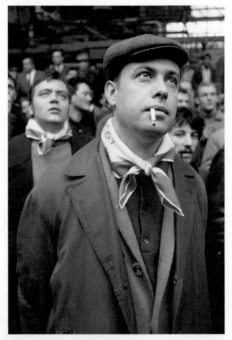
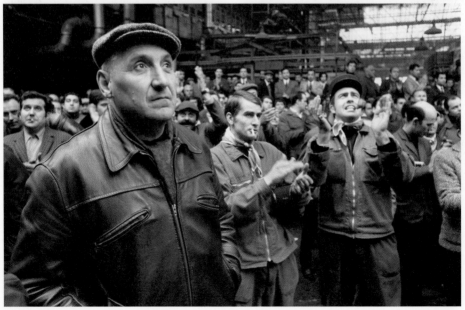

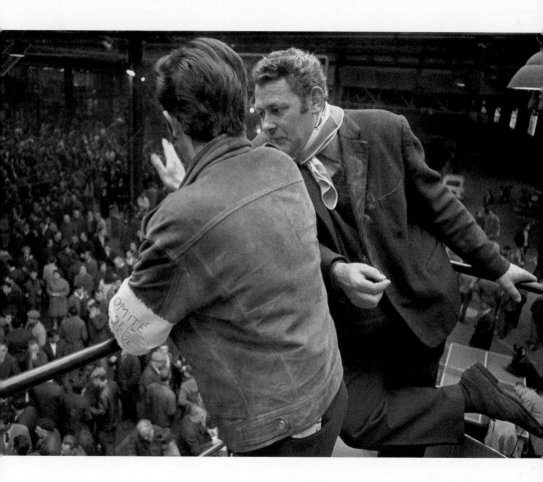

THESE AND SUBSEQUENT PAGES. Boulogne-Billancourt, Hauts-de-Seine, May 27th. Meeting of the CGT (French trade union) at the Renault car factory, during their strike. Strikers have gathered to listen to reports on the Grenelle Agreements (Accords de Grenelle).

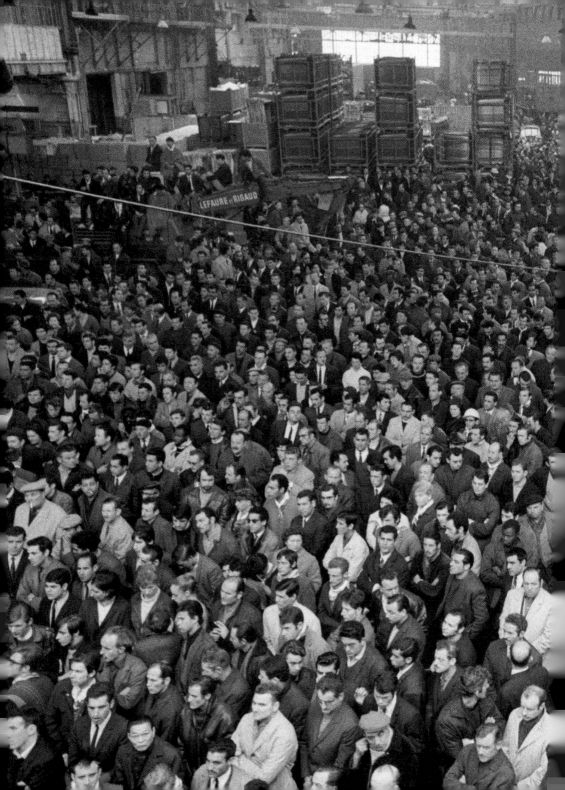

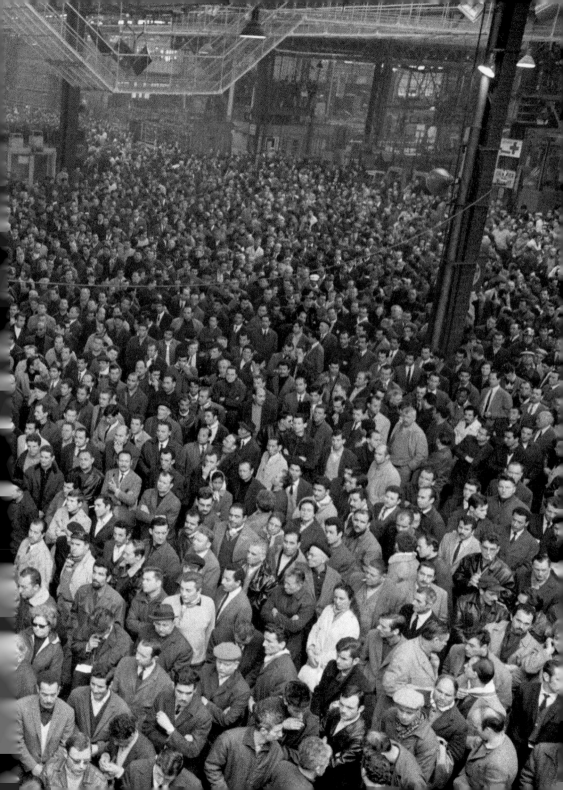

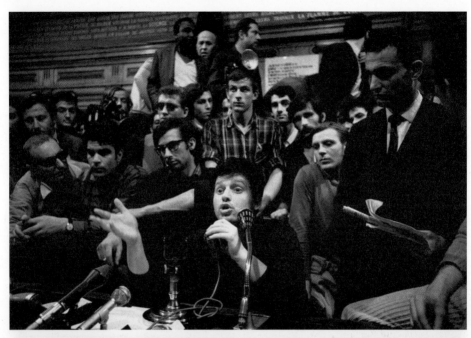

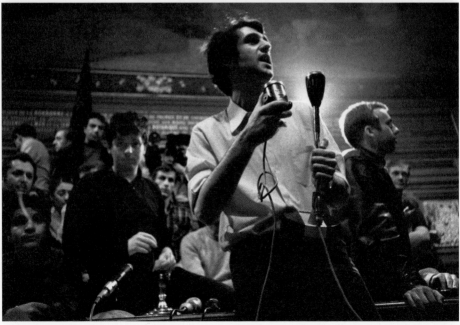

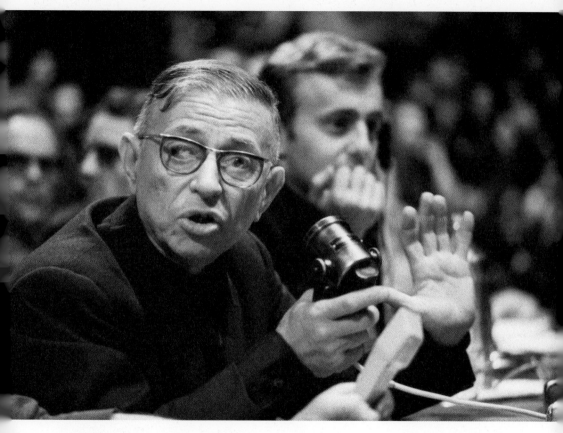

OPPOSITE, TOP. Sorbonne, 5th arrondissement, Paris, May 28th. Daniel Cohn-Bendit, one of the leaders of the student movement, speaks at a meeting in the amphitheatre..

OPPOSITE, BOTTOM. Sorbonne, 5th arrondissement, Paris, May 28th. General meeting at the Sorbonne. Henri Weber in the foreground, with Daniel Cohn-Bendit in the background. Weber was co-founder of the Ligue Communiste Révolutionnaire party in France; he went on to become a senator and a Member of the European Parliament, as did Cohn-Bendit, in later life.

ABOVE. Sorbonne, 5th arrondissement, Paris, May 28th. French writer and philosopher Jean-Paul Sartre at a student assembly.

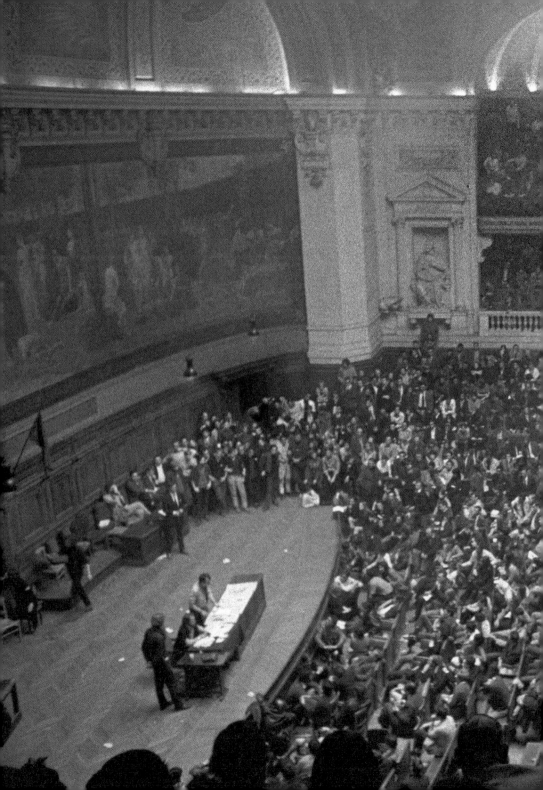

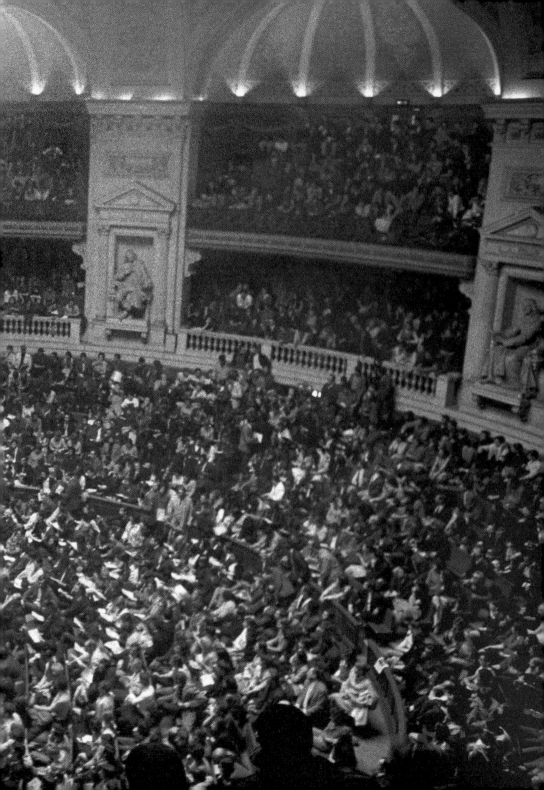

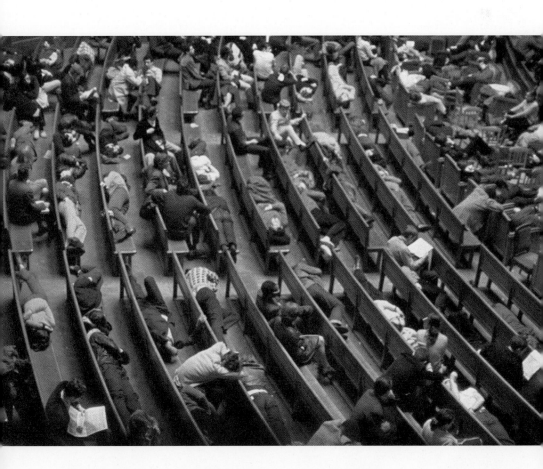

PRECEDING PAGES. Sorbonne, 5th arrondissement, Paris, May 28th. Student meeting at the Sorbonne. Black and red flags are set on the podium.

ABOVE. Sorbonne, 5th arrondissement, Paris, May 28th. After the student meeting, the Richelieu lecture hall in the Sorbonne doubles as a dorm.

OPPOSITE, TOP. Rue Saint Guillaume, 6th arrondissement, Paris. In front of the Institute of Political Studies (Sciences Po). The graffiti reads, "Politics for all."

OPPOSITE, BOTTOM. Rue Saint Guillaume, 6th arrondissement, Paris. Entrance hall of the Institute of Political Studies (Sciences Po) covered with Communist posters.

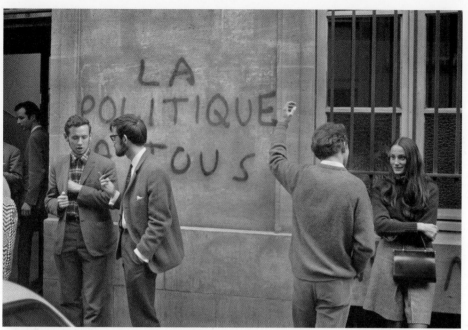

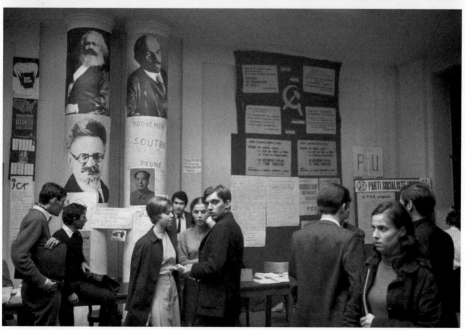

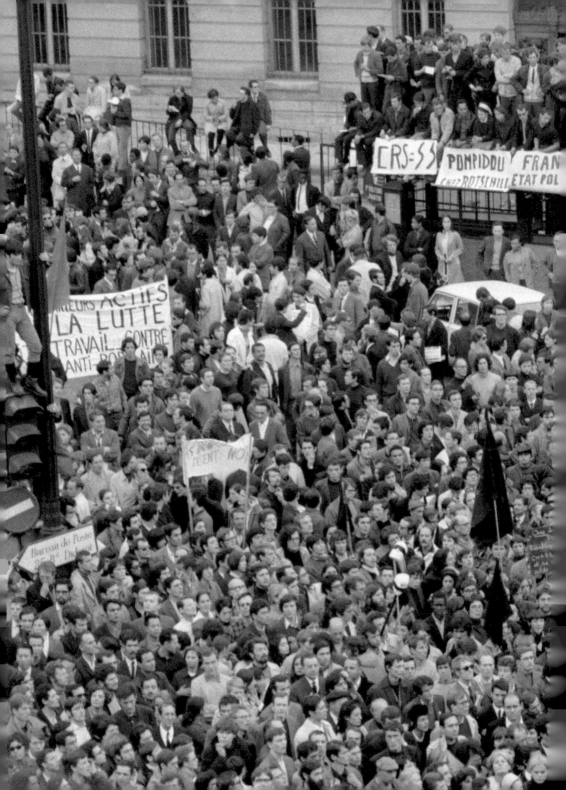

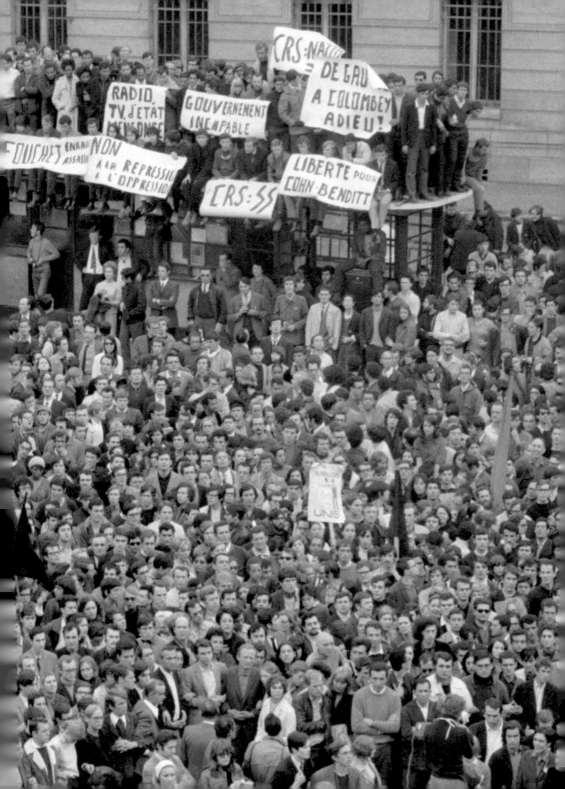

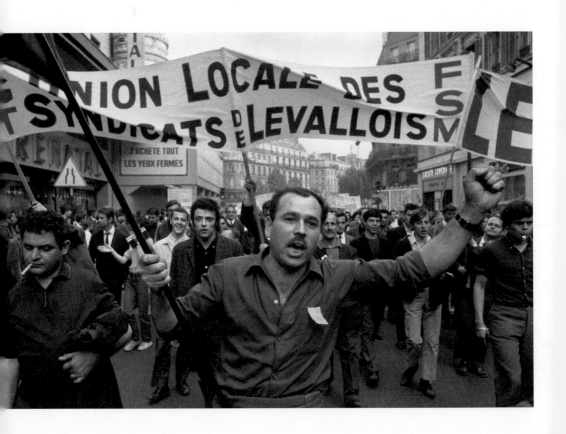

PRECEDING PAGES.
Saint Lazare Station,
8th arrondissement,
Paris, May 29th. The
CGT trade union holds
a demonstration.

ABOVE. Paris,
May 29th. Workers'
protest at the
CGT trade union
demonstration.

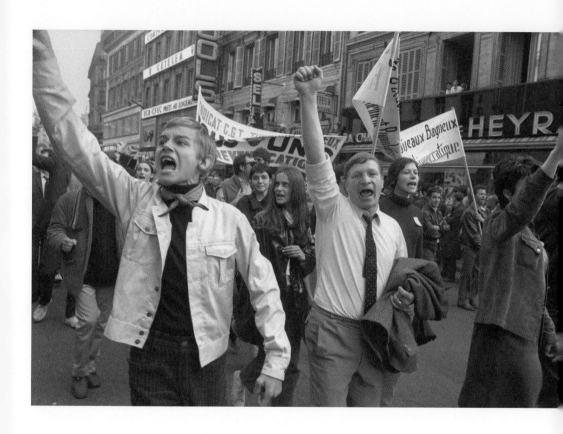

Paris, May 29th.
Workers' protest at
the CGT trade union
demonstration.

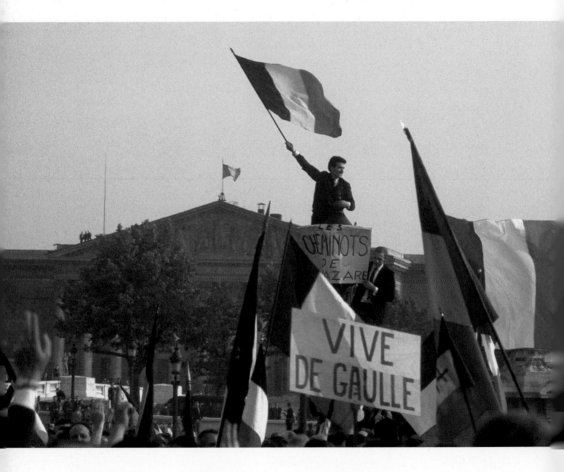

ABOVE. Place de la Concorde, 8th arrondissement, Paris, May 30th. Supporters of General De Gaulle wave French flags and brandish slogans.

OPPOSITE. Champs-Élysées, 8th arrondissement, Paris, May 30th. March in support of French President De Gaulle, from the Place de la Concorde to the Arc de Triomphe. Depending on the source, between 300 and 500,000 people were present.

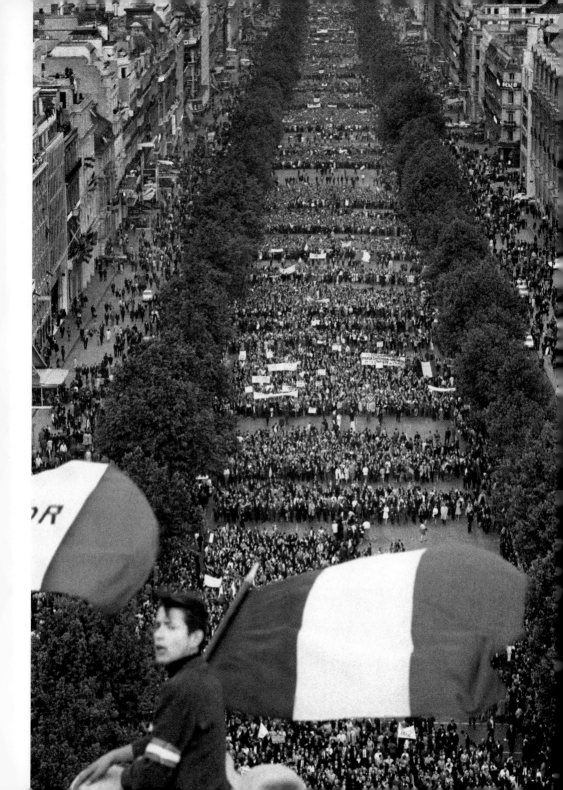

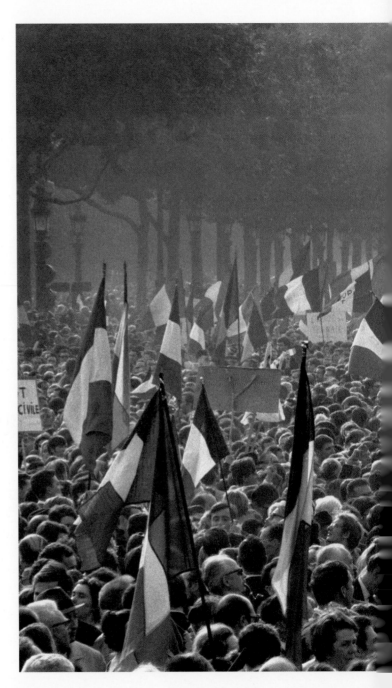

Champs-Élysées, Paris, 8th arrondissement, May 30th. March in support of President De Gaulle, from the Place de la Concorde to the Arc de Triomphe.

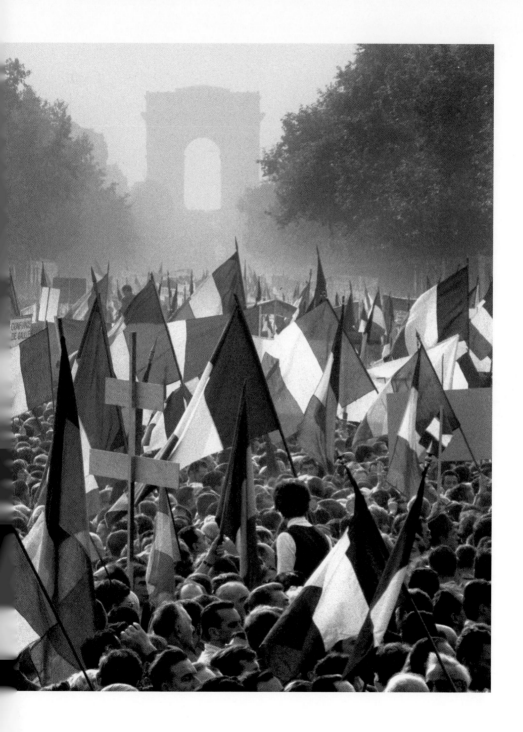

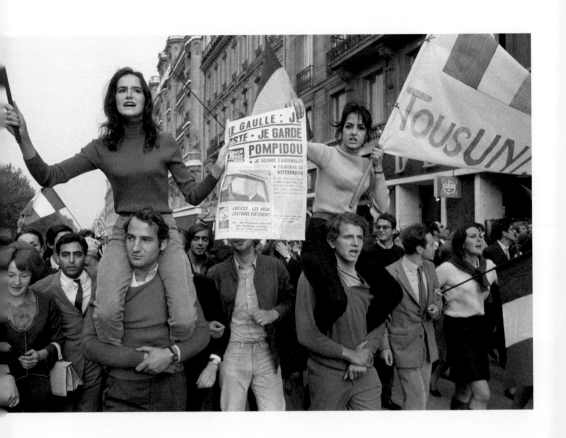

Champs-Élysées, Paris,
8th arrondissement,
May 30th. March in
support of French
President Charles
De Gaulle. A girl
brandishes a copy of
the newspaper *France
Soir*. The headlines
read: "De Gaulle [says]:
'I'm staying [and] I'm
keeping Pompidou'."

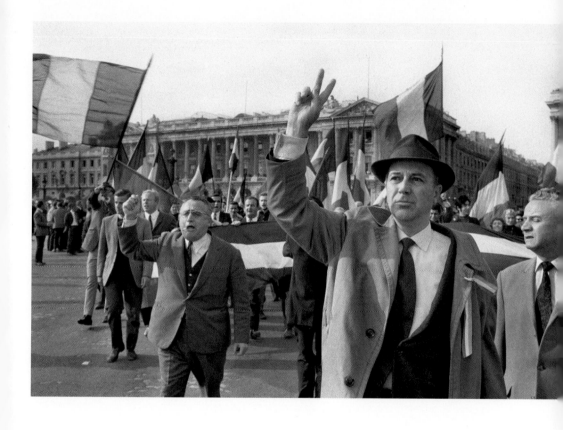

Place de la Concorde,
8th arrondissement,
Paris, May 30th.
Partisans of General
De Gaulle demonstrate
on the Place de
la Concorde.

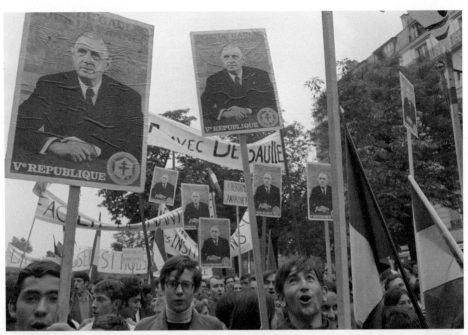

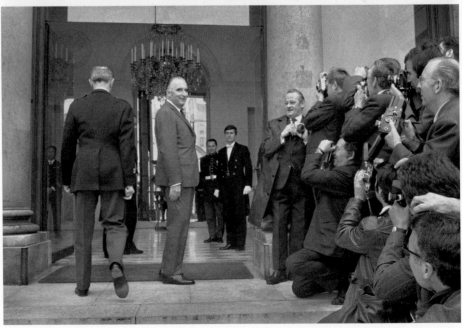

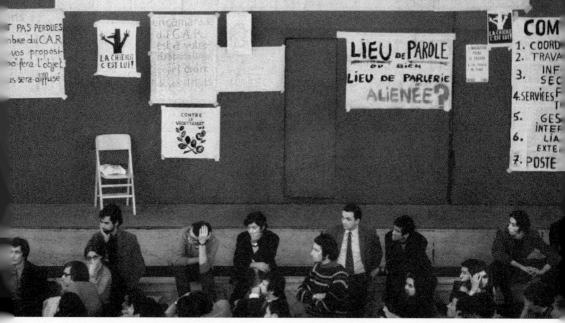

OPPOSITE, TOP. Place du Trocadéro, 8th arrondissement, Paris, May 30th. March in support of French President Charles De Gaulle, from Place de la Concorde to the Arc de Triomphe.

OPPOSITE, BOTTOM. Élysée Palace, 8th arrondissement, Paris, May 30th. Prime Minister Georges Pompidou leaves after a Cabinet meeting in which De Gaulle states his support for him.

ABOVE. Odéon Theatre, 6th arrondissement, Paris. Occupied by students since May 15th, it became a haven for protesters.

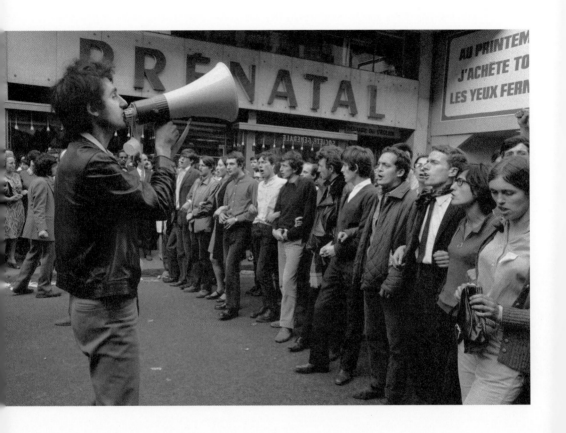

Paris, June 1st. Student
demonstration.

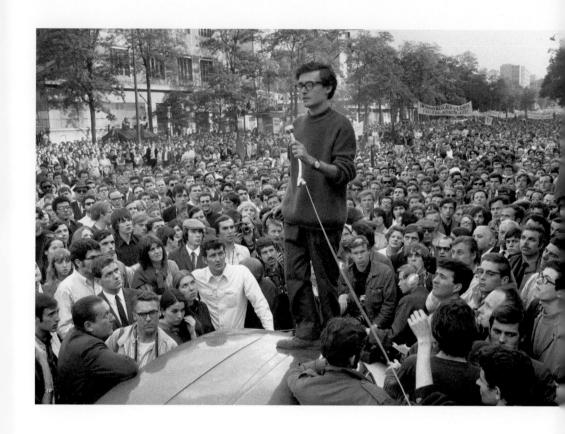

13th arrondissement
Paris, June 1st. Student
march from Boulevard
de l'Hôpital to Gare
d'Austerlitz.

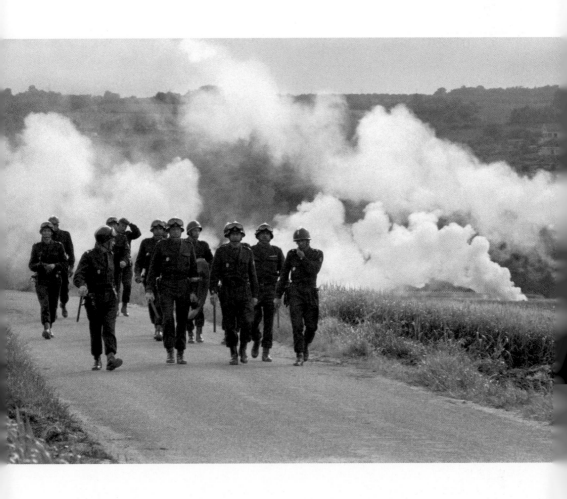

ABOVE. Flins-sur-Seine, Yvelines, June 7th. CRS riot police head for the striking Renault car factory.

OPPOSITE, TOP. Flins-sur-Seine, Yvelines, June 7th. Barricade near the Renault car factory.

OPPOSITE, BOTTOM. Bougival lock, Yvelines. Striking ferrymen block the Seine with barges.

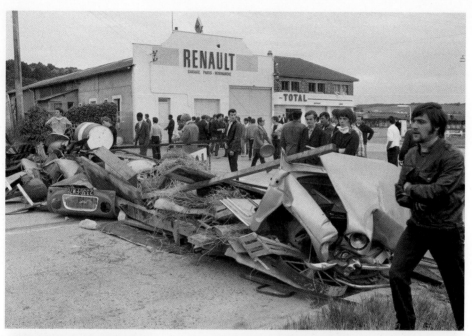

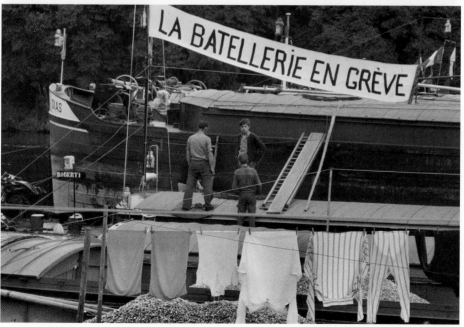

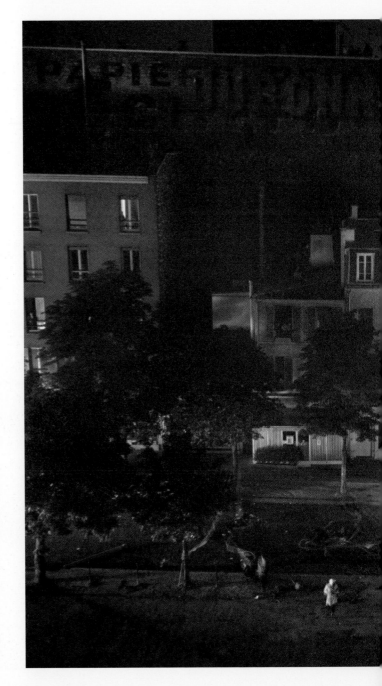

OPPOSITE.
Rue de Vaugirard,
15th arrondissement,
Paris, 4 am, June
11th. Barricades and
demonstrators fill
the streets.

FOLLOWING PAGES.
15th arrondissement,
Paris, June 10th. Riot
police take position
on the corner of
Boulevard Pasteur
and Rue de Vaugirard
in response to
a demonstration.

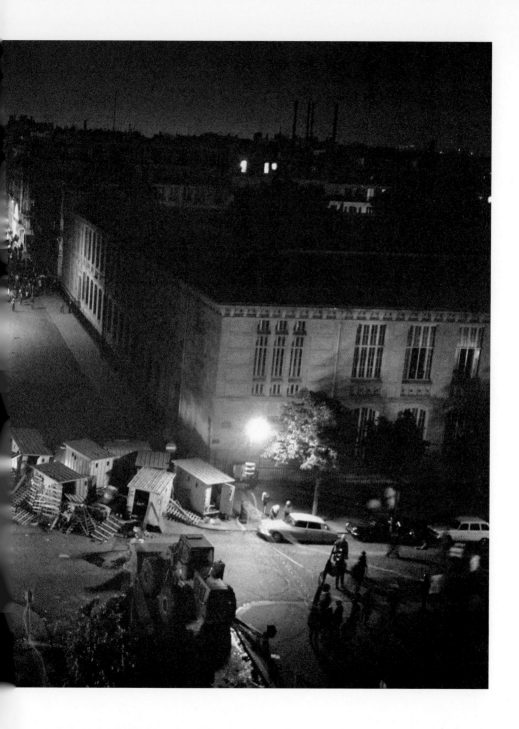

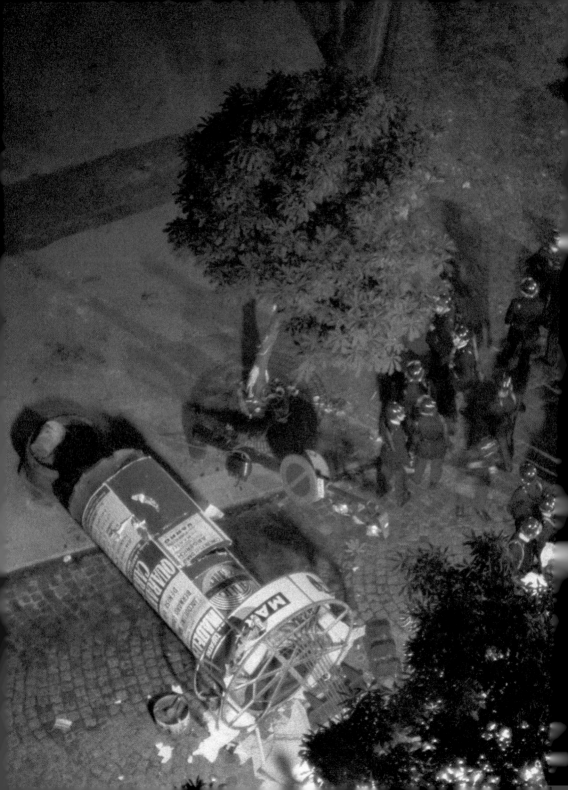

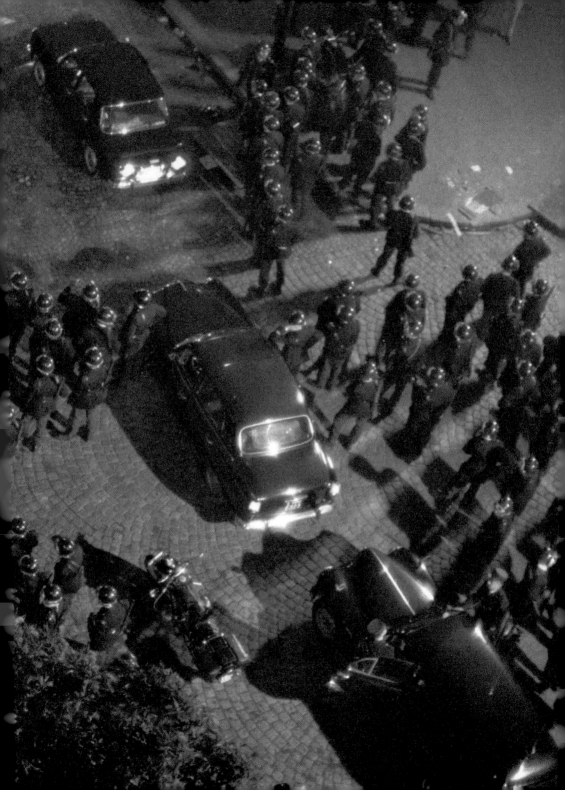

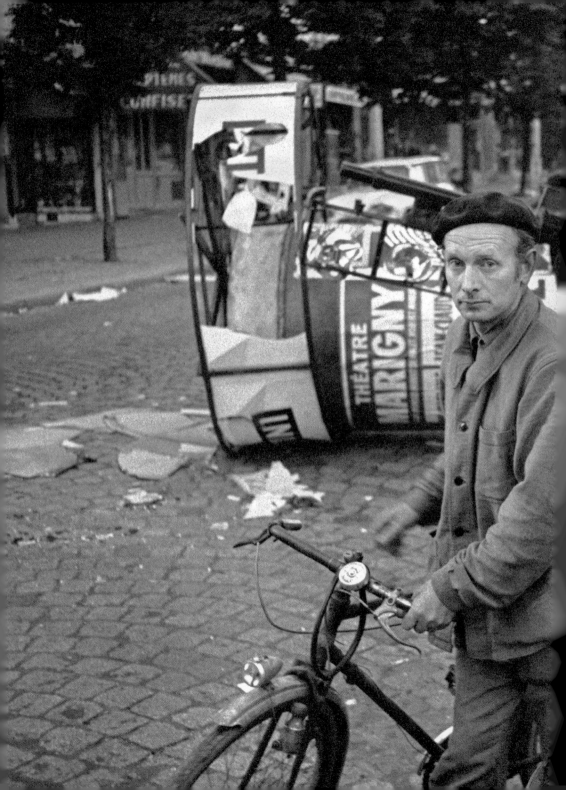

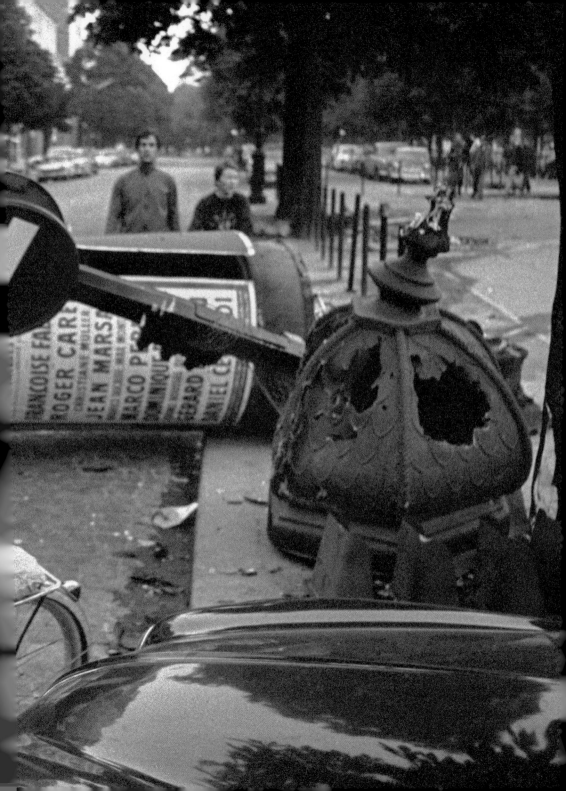

PRECEDING PAGES. Corner of Boulevard Pasteur and Rue de Vaugirard, 15th arrondissement, Paris, June 11th. Protester at the barricades after a night of riots.

ABOVE. Corner of Boulevard Pasteur and Rue de Vaugirard, 15th arrondissement, Paris, night of June 10th. Aftermath of the riot that took place the night before.

OPPOSITE. École de Médecine, Rue des Saints Pères, 6th arrondissement, Paris, June 12th. Around 6AM, Mustapha Saha, co-founder of the Movement of March 22, sits on a barricade awaiting the impending charge of the riot police (CRS).

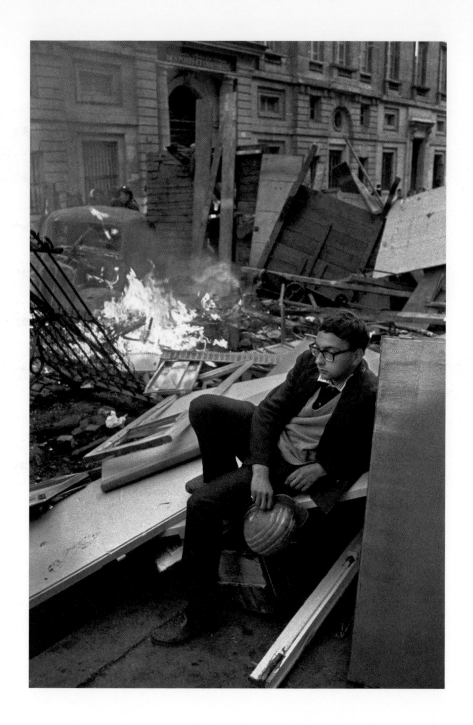

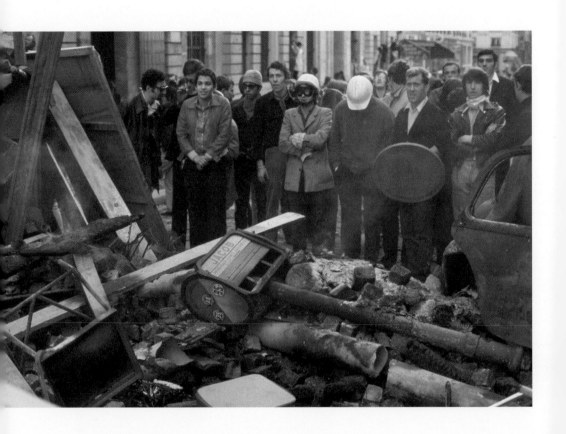

École de Médecine,
Rue des Saints Pères,
6th arrondissement,
Paris, June 12th,
around 6AM. Students
gather at the last
barricade in front of
the École; the police
would take it over
by 11 am.

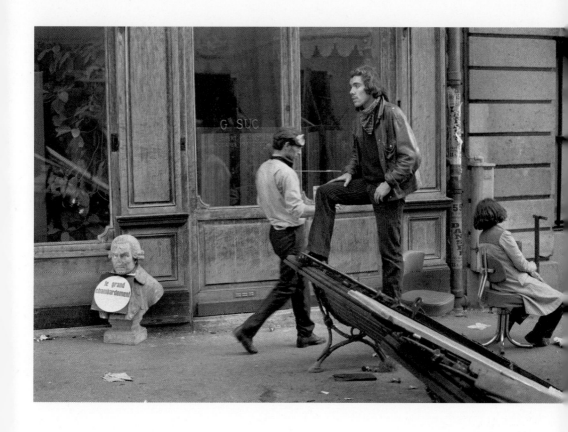

École de Médecine, Rue des Saints Pères, 6th arrondissement, Paris, June 12th. A student mans the last barricade in front of the École before its impending takeover by police. The nearby bust sports a sign that says "the Great Upheaval".

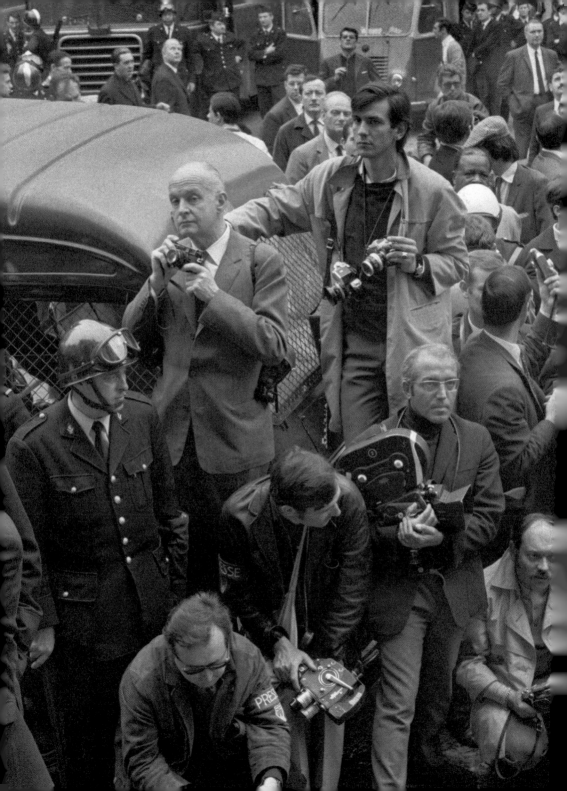

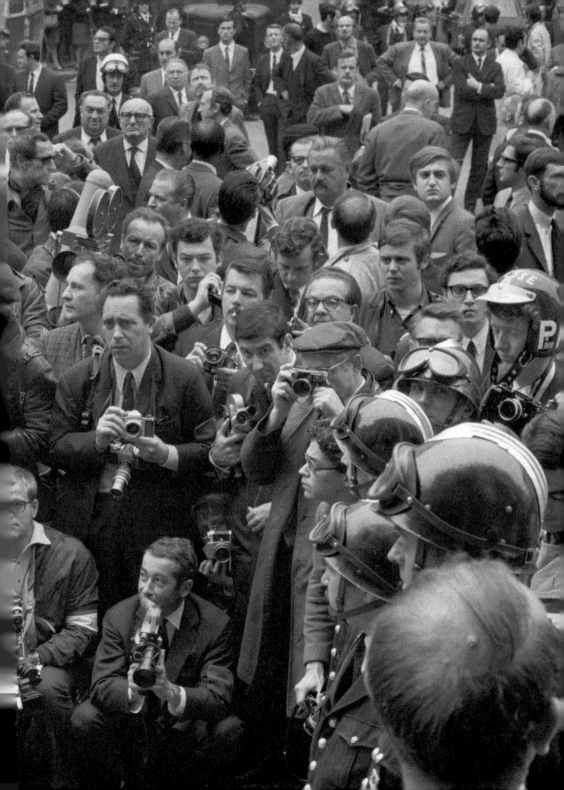

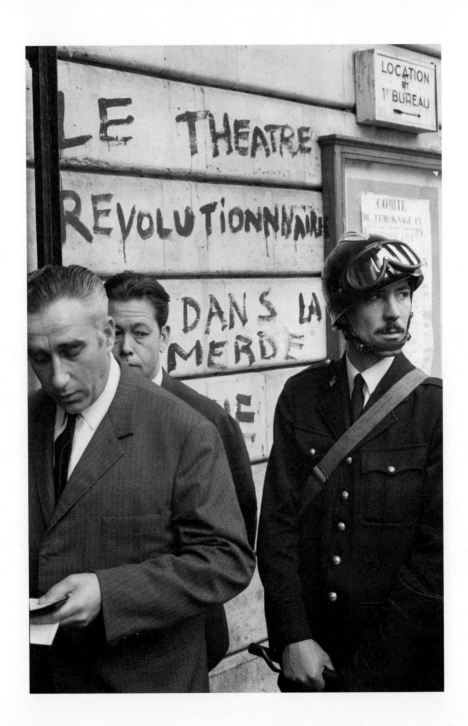

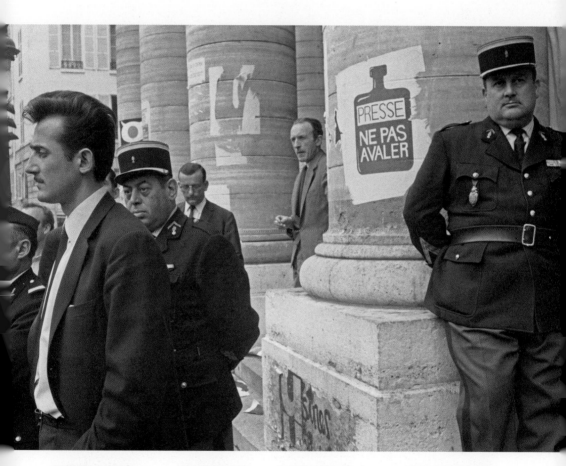

PRECEDING PAGES. Odéon Theatre, 6th arrondissement, Paris, June 14th. The press gathers in front of the theatre as it is being evacuated by the police.

OPPOSITE. Odéon Theatre, 6th arrondissement, Paris, June 14th. In front of the theatre, the graffiti reads "the Revolutionary Theatre is really in the shit".

ABOVE. Odéon Theatre, 6th arrondissement, Paris, June 14th. The police evacuate the theatre, after its occupation in May. The sign reads: "Press - do not swallow".

FOLLOWING PAGES. Paris, June 15th. The funeral of Gilles Tautin, a student who was drowned during a police raid at the Renault factory at Flins-sur-Seine (Yvelines).

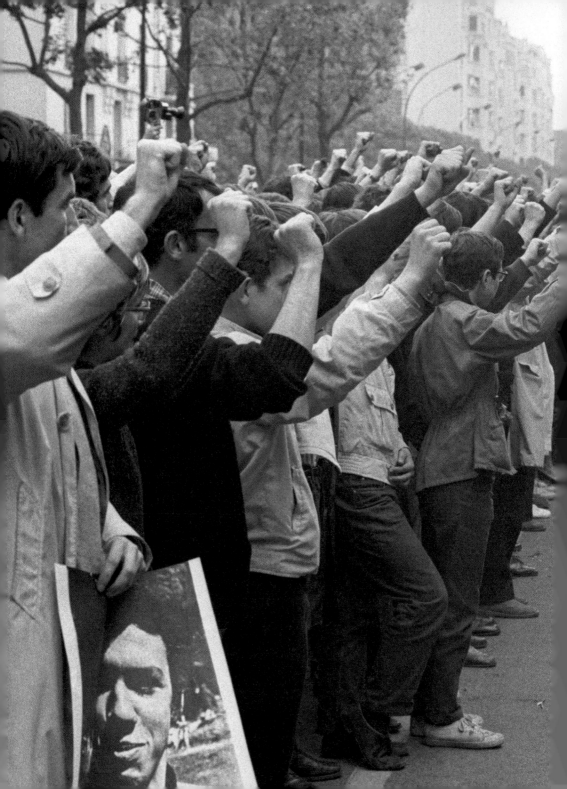

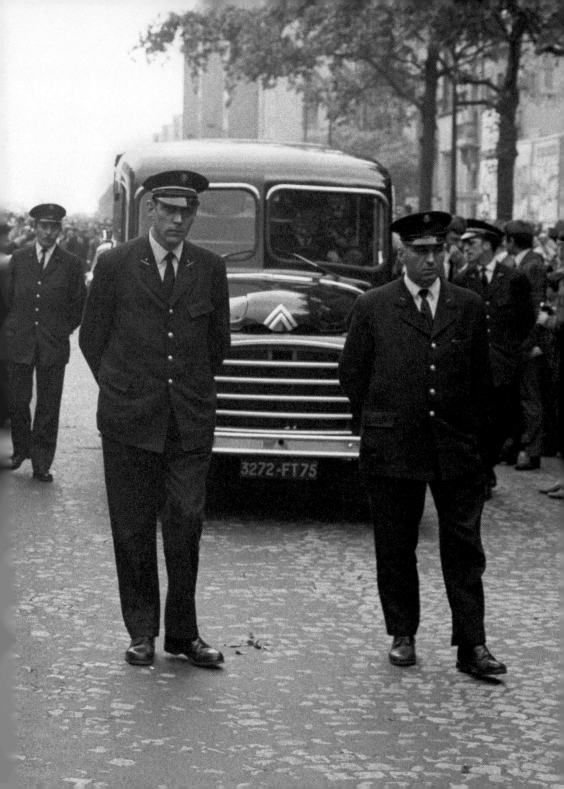

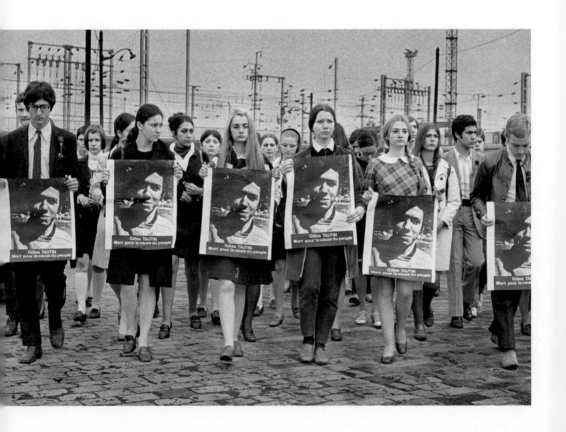

Paris, June 15th.
Demonstrators
bearing photos of
Gilles Tautin, a student
who was drowned
during a police raid at
the Renault factory
at Flins-sur-Seine
(Yvelines).

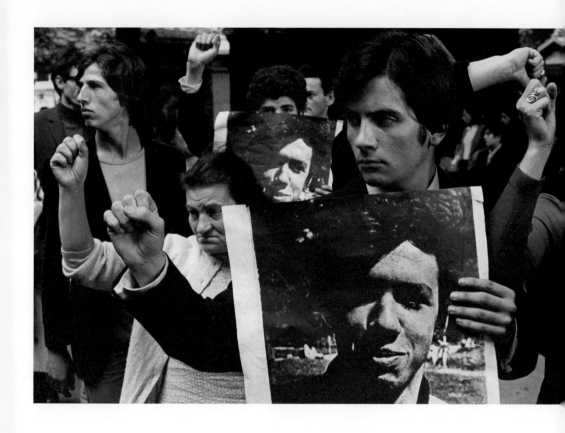

Paris, June 15th.
Demonstrators at
the funeral of Gilles
Tautin, a student
who was drowned
during a police raid at
the Renault factory
at Flins-sur-Seine
(Yvelines).

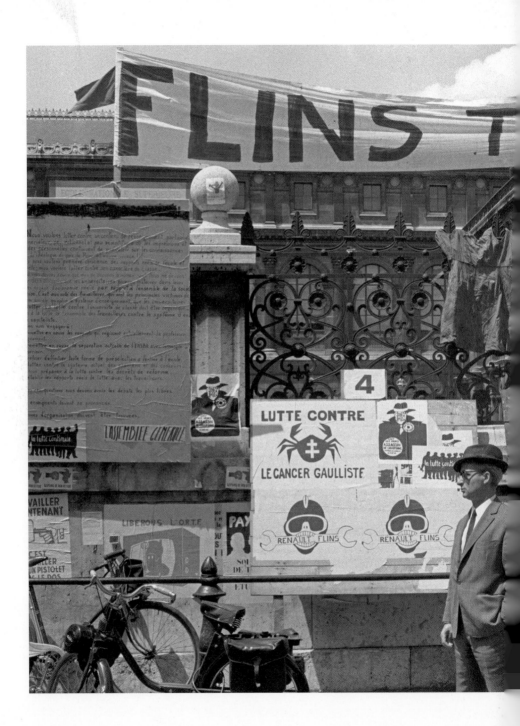

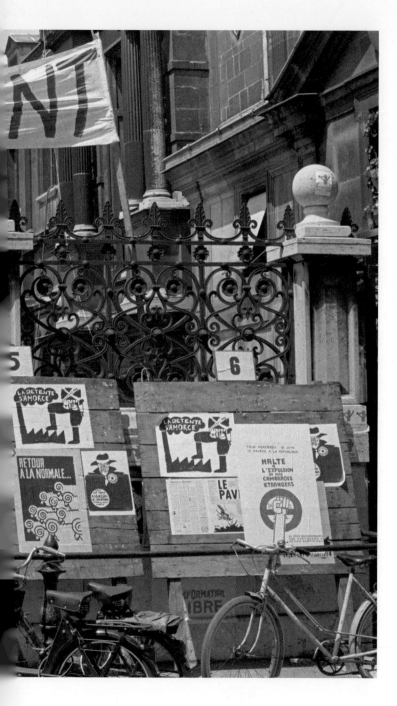

OPPOSITE. Ecole des Beaux-Arts, 6th arrondissement, Paris. Most of the iconic posters of May 68 were created here.

FOLLOWING PAGES. Faculté de Médecine (Medical College), Boulevard Saint Germain, 6th arrondissement, Paris. Posters of May 68 cover the walls. Among the slogans: "Light Salaries, Heavy Tanks!", "Down with Bureaucracy!" "The Struggle Continues!" "The Press is Toxic – Free Information!" "Reforms, not Chloroform!" "Solidarity between Students and Workers!" "Power to the People."

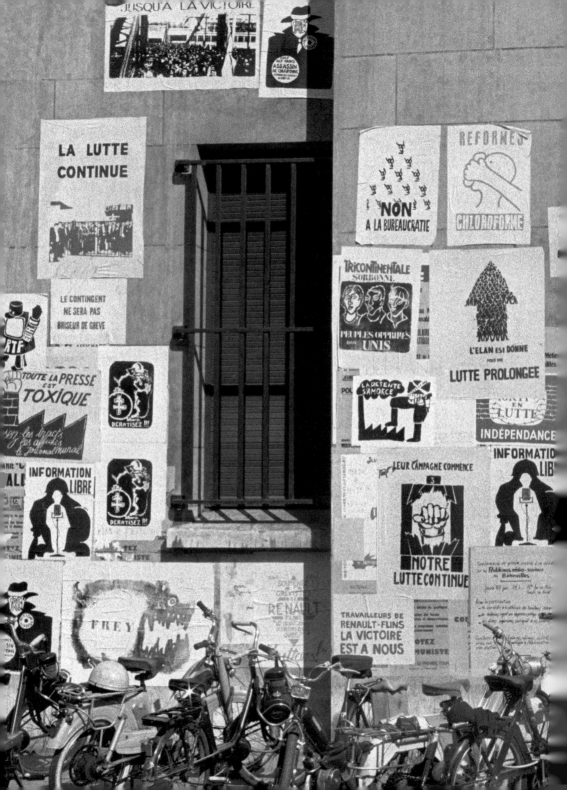

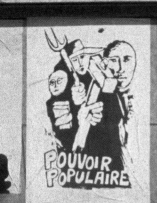

POUVOIR
POPULAIRE

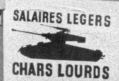

SALAIRES LEGERS

CHARS LOURDS

FREY

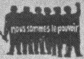

nous sommes le pouvoir

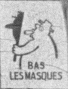

BAS
LES MASQUES

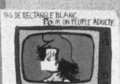

PAS DE RECTANGLE BLANC
POUR UN PEUPLE ADULTE

INDÉPENDANCE et AUTONOMIE de l'O.R.T.F.

ORTF

TROP TARD CRS

LE MOUVEMENT POPULAIRE
N'A PAS DE TEMPLE

solidarité
EFFECTIVE
étudiants
travailleurs

ORTF

L'ELAN EST DONNE
POUR UNE
LUTTE PROLONGEE

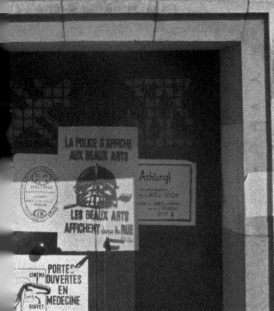

LA POLICE S'AFFICHE
AUX BEAUX ARTS

LES BEAUX ARTS
AFFICHENT dans la RUE

Achtung!

CINEMA
PORTES
OUVERTES
EN
MEDECINE

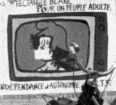

PAS DE RECTANGLE BLANC
POUR UN PEUPLE ADULTE

INDÉPENDANCE et AUTONOMIE O.R.T.F.

C.F.O

IN THE SAME SERIES

7 Days in Myanmar
by 30 great photographers

China, From Mao to Modernity
Photos Bruno Barbey
Texts Jean Loh

Istanbul
Photos Ara Güler
Texts Orhan Pamuk

Sinan
Photos Ara Güler
Texts John Freely & Augusto Romano Burelli

Creating the 20th Century, 100 artists, writers and thinkers
Photos Ara Güler
Texts Benoît Heimermann & Alberto Manguel

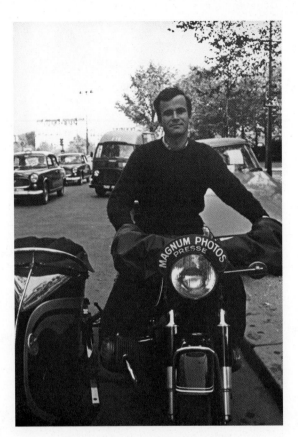

Photographer Bruno Barbey, May 1968.

Interior pages of this work were printed on Fedrigoni XPer Premium White 140 g/m^2 and Fedrigoni XPer Premium White 320 g/m^2 was used for the cover.

Éditions Didier Millet wish to thank Fedrigoni for their commitment and the SOPEDI for their invaluable advice.

Printed by Sopedi, France,
May 2018.